IMAGES
of America

NEBRASKA
STATE FAIR

IMAGES
of America

NEBRASKA
STATE FAIR

Mary L. Maas

ARCADIA
PUBLISHING

Published by Arcadia Publishing
Charleston, South Carolina

Printed in the United States of America

Library of Congress Control Number: 2010939908

For all general information, please contact Arcadia Publishing:
Telephone 843-853-2070
Fax 843-853-0044
E-mail sales@arcadiapublishing.com
For customer service and orders:
Toll-Free 1-888-313-2665

Visit us on the Internet at www.arcadiapublishing.com

This book is dedicated to the men and women who dreamed of what a Nebraska State Fair should be and made it so. It is also dedicated to the people who carried that vision forward and retained its history for all those who were not here for the first fair but can now experience the passage of time through the eye of a camera.

CONTENTS

ACKNOWLEDGMENTS

This book would not have been possible without the encouragement and support of Ted Gerstle, my editor at Arcadia Publishing. I want to thank Patricia Churray and Linda Hein from the Nebraska State Historical Society for being so gracious and generous with their time and information in assisting me in my research. My deepest appreciation to Lindsey Koepke, executive director of the 1868 Nebraska State Fair Foundation, for providing full access to the photographs that made up the majority of those used in this book. Those are the photographs which do not have a credit listed—with the exception of those in chapter nine, which are from my personal collection. I would like to express my thanks to Don McCabe, editor of *Nebraska Farmer Magazine*, for allowing access to the collection of photographs that have been credited to his publication in this book. Scott Yound in Grand Island deserves a big thanks for taking time from his very busy schedule to unlock the doors that held the files.

I want to recognize the photographers who captured history through the lens of their cameras and those who kept safe and preserved those photographic memories. I want to express my appreciation to my proofreader who was always available to help. I appreciate any and all assistance and encouragement I received from family and friends during this project.

INTRODUCTION

In 1980, the Nebraska State Fair lured more than a half a million visitors to savor the sights and sounds of spectacular events. From the earliest territorial fair held in Nebraska City in September 1859, before Nebraska was a state, to the last day of the Nebraska State Fair being held in the Lincoln location in 2009, millions of fairgoers have been drawn to the extravaganza.

The fair provides a venue for the agricultural backbone of Nebraska to display the biggest, the best, the newest, and the greatest for farmers, 4-H members, and Future Farmers of America members, as well as anyone who has the talent to compete for the championship prize in the open-class exhibits.

There is a rhythm that stirs the excitement for all who walk through the gates. From the steady hum of thousands of voices to the thrumming of equipment hooked up to the exhibitions and concessions, one is surrounded by the din of activity. The sound of horseshoes clicking on the pavement to the drums of the marching bands in the parades add to the enticements of hawkers plying their wares.

The grandstand shows echo the sounds of screaming engines of tractors pulling heavy loads and the crunch of metal fenders in the demolition derby. Professional dancers twirl, and musicians coax the crowds to stop, watch, and listen. Acrobats and daredevils perform death-defying acts in front of an audience holding its collective breath.

The livestock barns have rows and pens of cattle, horses, sheep, goats, and pigs. They range in size from wriggling newborns in the birthing barn to the biggest draft horse and heaviest hog. There are hundreds of fowl exhibited, from exotic breeds of chickens and waterfowl to birds and pigeons.

The fair has something for everyone, young and old, to enjoy. There is food to satisfy every palate—from snacks on a stick to full meals of mouthwatering cuisine. From the staple of cotton candy to deep fat–fried Twinkies or Snickers bars, every sweet-tooth fantasy can be satiated at the annual state fair.

The aim each year is to make the fair bigger and better. Something new is introduced to entice attendees to return year after year. The exhibits of the old next to the new comparing the past to the present were on display in Heritage Village. The buildings and items were gathered to show how it once was in early Nebraska. This historical display is now visible at the nearby Stuhr Museum in Grand Island. Antique farm equipment is set in motion, demonstrating how labor-intensive farming was, from planting to harvest. A short walk takes visitors out of the past and forward into the world of cyberspace.

The midway and the rides are some of the biggest draws for children and adults. From the ever-present carousel to the high-flying swings and Ferris wheels, there is something to satisfy any adventurous appetite of every age.

Through the century of fairs, there have been horse races, harness races, the first circus ever offered at a state fair, musicians, clowns, acrobatic troupes, fireworks, aerial performances, and magic acts from amateur talents to well-paid professional presentations. Photography, artwork, needlework, woodworking, quilts, flowers, vegetables, fruit, and food competition entries from throughout the state are judged and awarded ribbons and premiums.

The fair has not existed through the years without difficulties. The first territorial fair was not able to pay all premiums, as receipts collected were not enough to cover the expenses. As a result, a second fair was not held for seven years. Inclement weather has dampened and chilled attendance numbers. Accidents have occurred, resulting in injury and sometimes, sadly, the death of people or animals.

The early fairs did not have a permanent base, so interested counties or communities were required to submit bids, with the highest donations and accommodations receiving the honor for that year. The fairs were held in Nebraska City, Brownville, Omaha, and Lincoln until 1901, when Lincoln was made the permanent location for the annual Nebraska State Fair by vote of the legislature. In the 140 years since the first territorial fair, Lincoln held 108 Nebraska State Fairs, until 2008, when the state legislature voted to move the fair site to Grand Island. The town, located in central Nebraska, is building new facilities and promises to carry on the tradition of making every fair the best it can be.

Inclement weather has stressed budget funds, with seven inches of rain causing huge deficits in 1914. In 1989, ten inches of rain created big problems when wreckers had to pull vehicles through the deep mud on the grounds. There were several fires that destroyed buildings. The large cattle barn burned to the ground in 1919, and the Lincoln business community raised $150,000 to replace the building. There were failures of equipment or rides that caused several injuries, and two horses died in a chariot race during the 1970 fair.

Special centennial recognition was awarded to the Retzlaff family in 1967 for regular attendance at the fair. Others have since been given special accord for longevity of loyalty in attendance and support. Families who have owned and lived on their land continuously throughout the generations, for at least 100 years, have received plaques and celebrity treatment. Awards are given for conservation practices and being an all-around paragon in the community.

Some of the most popular attractions are horse races, trotter and harness races, car races, tractor pulls, and pony and draft horse pulls. The tractor pulls include male and female drivers of garden tractors, modified tractors, and regular tractors. Demolition derbies, daredevil auto stunts, and monster trucks are still big crowd-pleasers. Bands, singers, country-and-western stars, and parades are greeted with enthusiastic audiences year after year.

In 1898, there was no official Nebraska State Fair because Omaha hosted the spectacular Trans-Mississippi Exposition, also known as the world's fair. In 1942, the parades were without rubber or gas due to shortages in World War II, and in 1945, the government, in deference to the end of the war, canceled the fair. In 1980, there were 505,800 total admissions at the gate.

The final year in Lincoln drew a total crowd of over 367,000 during the 11-day run. Though Lincoln is saying a sad farewell to more than a century of tradition, Grand Island is looking forward to a spectacular opening for the first annual Nebraska State Fair in their city in 2010. The welcome banners are flying high, the brand-new buildings are waiting to be filled, and the volunteers are hundredfold and ready to make the new Nebraska State Fair a truly memorable and grand affair.

One

THE EARLY YEARS

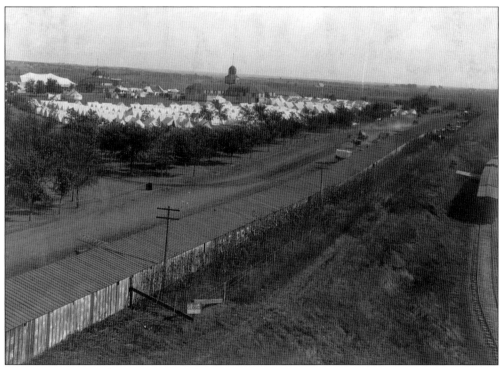

A distant view of the 1880s Nebraska State Fairground in Lincoln reveals the many tents of vendors and exhibitors. Fairgoers stayed in tents on the grounds because rooms were expensive and few were available. Horses and wagons make their way to the front gate on the right. The Agricultural Hall is prominent in the center of the photograph. Seen on the lower right edge of the picture, a train wends its way on the tracks. (Courtesy of the Nebraska State Historical Society, RG3356-04-07.)

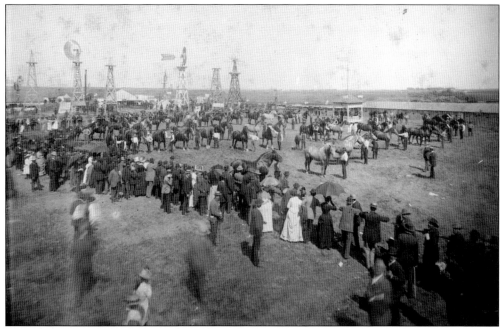

Men, women, and children standing along the fence line watch the State Horse Herd as the horses are paraded and judged in the show ring at the annual fair in Lincoln during September 1888. A number of windmills have been erected for display in the background. (Courtesy of the Nebraska State Historical Society, RG3356-03-07.)

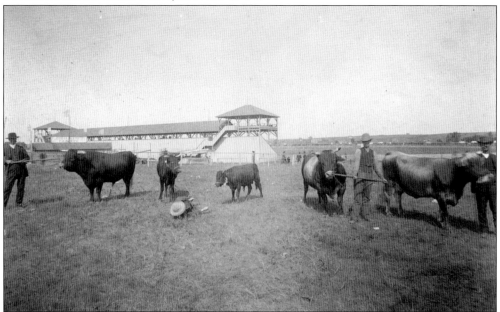

These proud owners of Devon and Brown Swiss cattle bring the best of their herds to compete at the 1888 Nebraska State Fair. The young man in the middle appears to have lost the tug of war with his two charges, while the somber gentlemen on either side control their bovine with a pole attached to a ring in the bull's nose. The large grandstand is behind on the left. (Courtesy of the Nebraska State Historical Society, RG3356-03-16.)

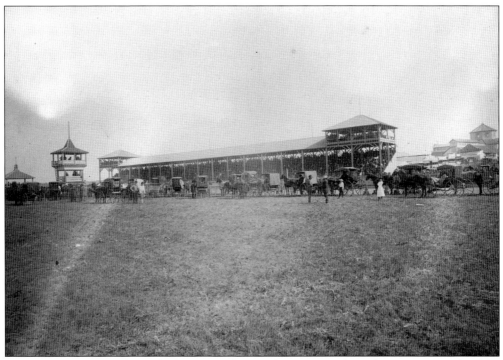

The Lincoln fairgrounds amphitheater can be seen here in 1888 from the quarter stretch of the racetrack. A group of horse-drawn, four-wheel carriages carrying men and women are waiting on the center field of the track to start their procession in front of the grandstand spectators. (Courtesy of the Nebraska State Historical Society, RG3356-03-01.)

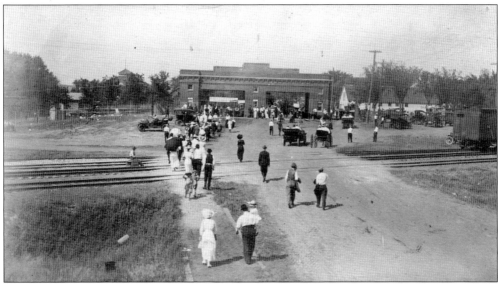

Early-1900s fairgoers stream toward the large double-access gate on foot, in horse-drawn carriages, and in automobiles. They line up to purchase tickets at three windows at the gate. The fair was considered a special occasion, and patrons are dressed in their Sunday best, with fancy hats, white shirts, suits, and ties. They cross four sets of railroad tracks and pass a railcar stopped on the right side of the main thoroughfare.

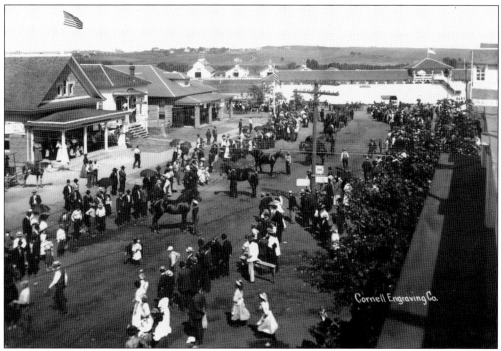

The Nebraska State Fair horse show of June 26, 1909, parades down the main street of the fairgrounds, drawing the attention of many. New buildings line the thoroughfare, and the walkways look to be hard-surfaced. A small girl and her pony lead the procession of horses, mules pulling wagons, and horse-drawn carriages. New livestock barns are seen beyond the large grandstand in the distance. (Courtesy of the Nebraska State Historical Society, RG3356-09-11.)

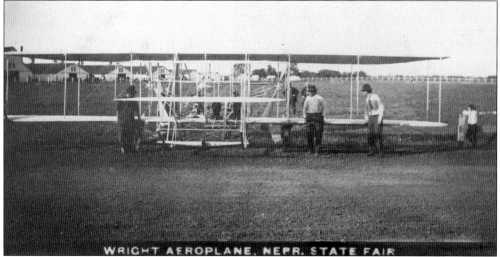

In 1910, Nebraska State Fair officials contracted with the Wright brothers to bring their airplane to the fair at a cost of $10,000. They arranged for four flights per day—two in the morning and two in the afternoon—with the ascension and landing to take place on the center field of the racetrack. However, during the week, the exhibited airplane crashed, which brought the flights to an end, as another plane could not reach the fair before it ended. (Courtesy of the Nebraska State Historical Society, RG3356-PH-10-05.)

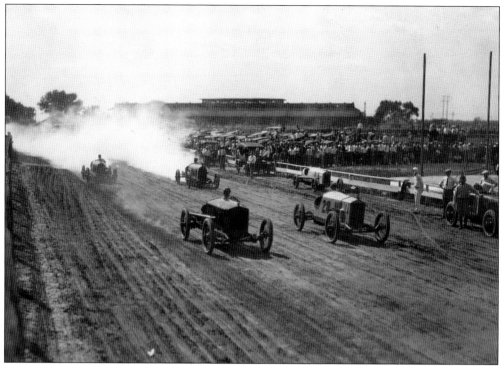

The car races were a popular event during the 1914 Nebraska State Fair in Lincoln. Dust and exhaust fumes fill the air as car No. 28 is in a dead heat with the challenger on its left. (Courtesy of Nebraska State Historical Society, RG3356-10-02.)

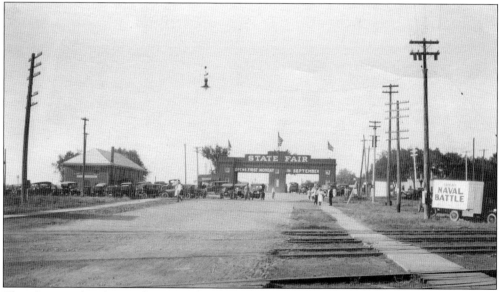

This photograph, taken in the 1920s, shows a new marquee above the main gate entrance into the Nebraska State Fairgrounds and advertises the fair opening date as the first Monday in September. An entertainment or exhibit trailer with the signage "Naval Battle" sits on the right. The white Education Building is in the upper right, and a brick building has been erected to the left of the entrance, which replaced some yards and homes.

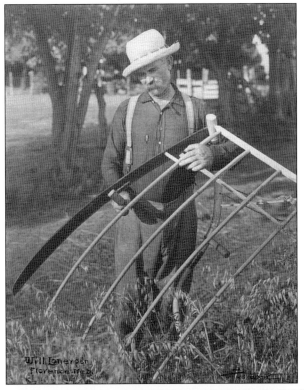

Will Lonegren of Florence, Nebraska, demonstrates the use of a scythe and rake combination tool for harvesting grain by hand. This photograph is dated 1924.

The Burt County dairy judging team won first place and earned, as their award, a trip to Memphis, Tennessee. There they would represent the state at the national judging contest. The photograph below is dated April 6, 1928, and identifies the four gentlemen from left to right: Howard Petersen; Arthur Petersen; W.B. Adair, Burt County extension agent; and LaVern Petersen.

An elderly couple pauses outside a brick building on the Nebraska State Fairgrounds. Two young boys hawk the day's newspapers in the background while stretching to be included in the photograph. In the 1930s, the mode of dress was suit and tie for the men. Ladies wore longer length dresses and a fashionable hat when attending social events such as the fair.

The top spelling bee winners in Nebraska pose for a photograph after their success at the final state fair competition in 1926. Most school districts held local spelling bees, and winners worked up through the contests to compete at the top. Each county had a top speller to represent it at the state spelling bee. The only identification found for these two young ladies are the contestant numbers 18 and 20 pinned on their bodices.

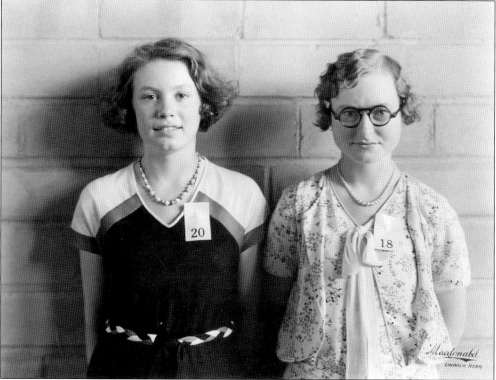

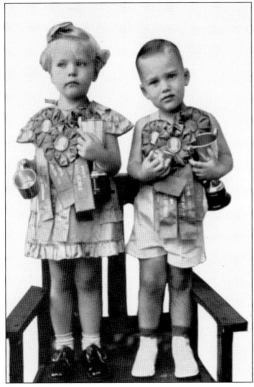

Healthy baby contests were first held in 1934 during the 80th anniversary of the Nebraska State Fair. All toddlers 18 to 36 months of age were eligible on September 1, 1934. The contest was held to promote the importance of mental and physical well-being of babies. The 1938 champions, pictured at left with their ribbons and trophies, are Jeanice Faye DeVries of Hickman, Nebraska, and Jack Glen Fuller of Lincoln. These contests were discontinued due to fears of contagion during the polio epidemic.

A scrub bull sporting the name of the Nebraska town "Rising City" stands near a loading chute located next to a set of railroad tracks. Knotted ropes around the bull's horns hold it safely in place in this photograph dated August 26, 1925. A shadow of the tethered rope secured to something on the left out of view is seen on the ground in front of the bull's nose. It was noted that the scrub bull was exchanged for a purebred Holstein.

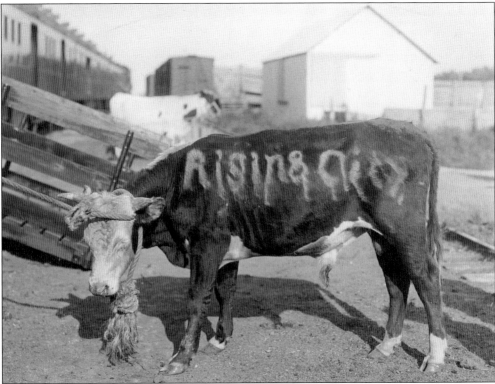

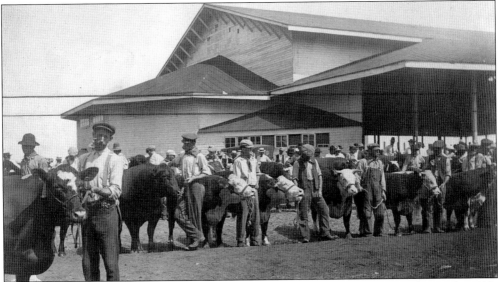

Cattle entries to be judged in an open-class beef show line up near the open-air arena in the 1930s photograph above. Below, an unidentified young lad holds tightly to a frisky foal that appears to have no lead rope or halter. This picture is dated August 30, 1929.

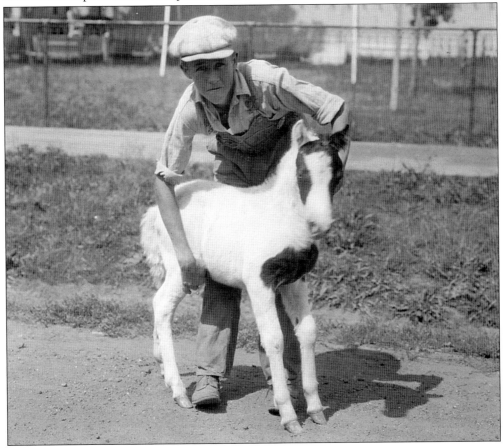

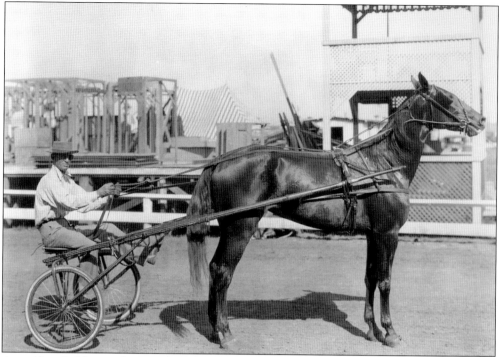

An unidentified driver in his two-wheeled cart has his steed harnessed up and ready to race on September 5, 1931. On the left behind the driver, the stage is under construction for grandstand entertainment. The announcer's booth is directly behind the horse, providing a full view of the area.

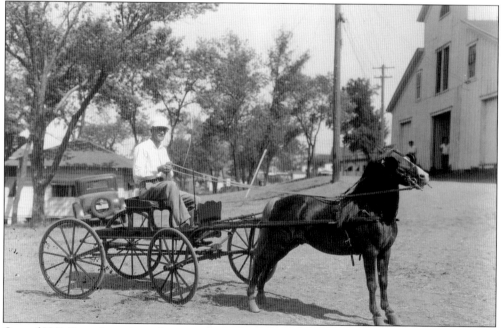

One of H.E. Sturm's ponies is harnessed to a four-wheel buggy for a photograph opportunity in front of a large livestock barn during the 1931 Nebraska State Fair. Horse races took place in many forms and were some of the most popular contests for patrons to enjoy.

Two

Early Vendors
and Exhibits

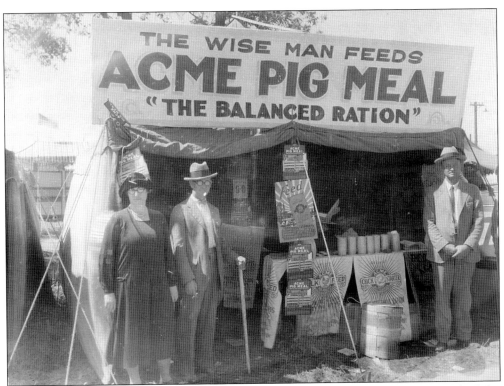

A 1920s vendor display declares Acme Pig Meal as "the balanced ration" feed. The tented exhibit displays feed sacks, with products available for chicks, poultry, pigs, and calves. The gentleman on the left carries his walking stick for the stroll on the grounds.

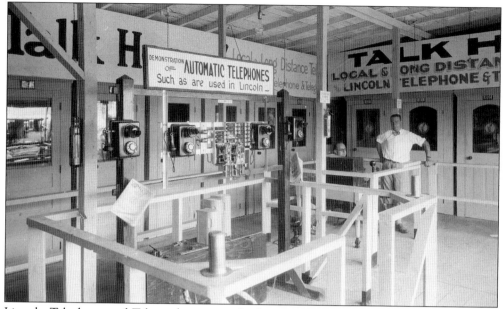

Lincoln Telephone and Telegraph presents the latest in automatic telephones in their 1920s exhibit. These new rotary dial telephones can be used for local and long-distance calls and are crank-free. The doors on the back walls appear to be phone booths, perhaps offering fair patrons the opportunity to test out the latest communications technology.

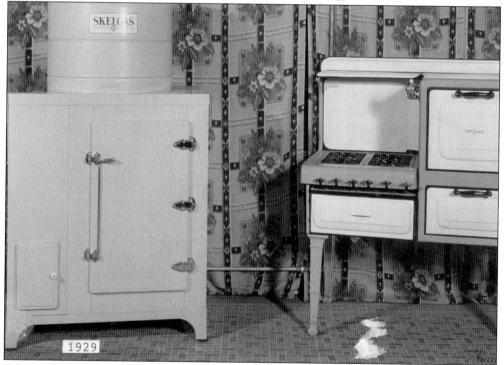

In 1929, the Skelgas Company displayed a gas-powered refrigerator and four-burner stove in their commercial exhibitor's booth. The attractive kitchen setting features a curtained backdrop and linoleum-covered floor to entice the lady of the house with their newest propane appliances.

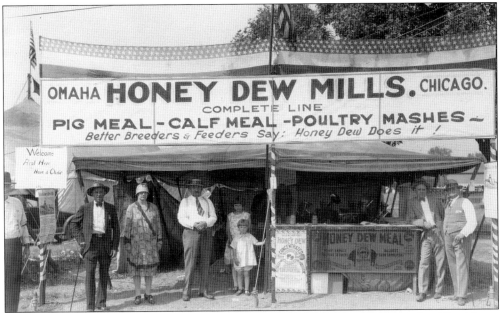

This photograph shows one of the bagged-feed competitors at the 1920s state fair. The Honey Dew Mills of Omaha and Chicago have a live band playing inside the tent to help draw attention to their product line of chick and pig starter feeds. The small banner within the tent advertises Honey Dew Meal for "pigs, calves lambs & colts" on the left side. On the right of the small banner, feed additives for "cows horses hogs & sheep" are advertised.

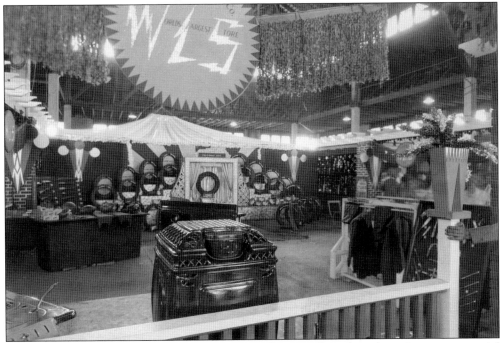

The World's Largest Store, or WLS, presents a full array of retail products for its commercial display in the 1930s. Customers who visited the store found clothes, tools, tires, guns and sports equipment, decorative heating stoves, cook stoves, and fancy wall clocks.

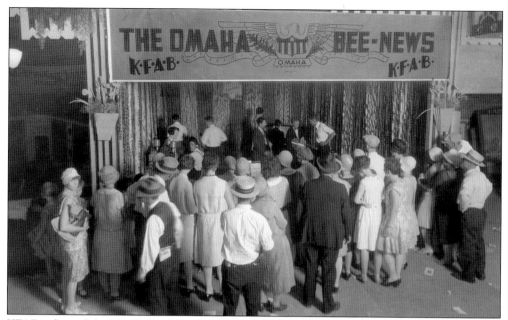

KFAB radio and the *Omaha Bee-News* held live broadcast interviews with members of the audience at the 1930s state fair in the Exhibition Hall. KFAB was first licensed in Lincoln in 1924 and later licensed in Omaha. Founded in 1871, the *Omaha Bee-News* was a pioneer paper and the first regional newspaper in Nebraska; it was also known as a Republican newspaper. It merged with the *Omaha Herald* and was sold to William Randolph Hearst in 1927. Ten years later, he sold it back to the *Omaha World Herald*, which dissolved the *Bee* portion of its operation.

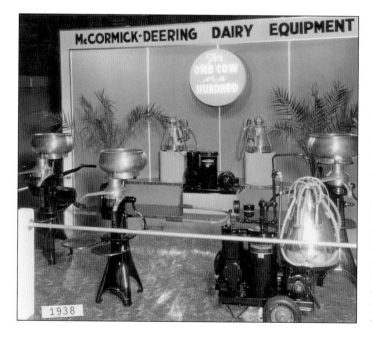

McCormick Deering Dairy Equipment Company brought their newest models of cream separators and automatic milking machines to the fair in 1938. These cream separators were run by hand, and the operator turned a handle to spin the cream out of the milk. The milking machines were motorized and mounted on a two-wheeled cart. A sign declares the machines would be good "for one cow or a hundred."

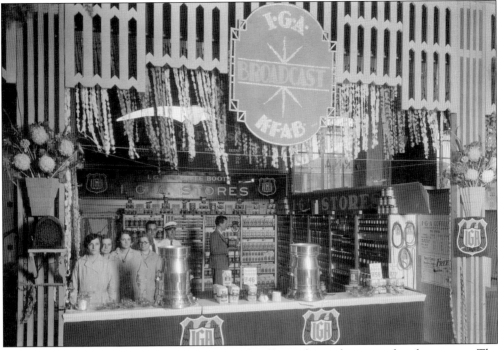

A commercial vending booth in 1930 dispensed coffee to those who stopped at the counter. The KFAB radio station broadcasted live from the booth and probably advertised the groceries and goods available from the Independent Grocers Alliance, which was established in 1926. There were 150 merchants in the alliance by the end of that year. By 1930, there were 8,000 members. Their slogan became "Hometown Proud Supermarket."

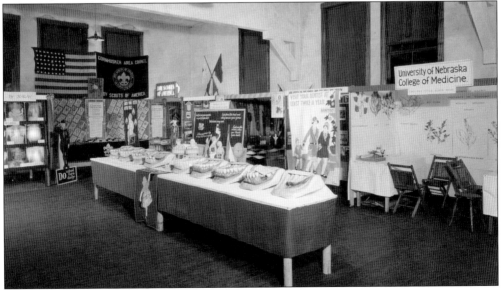

The Boy Scouts of America exhibited their flag and a 48-star American flag above the Scout's Oath and explanations of each badge. The University of Nebraska Medical and Dental Colleges displayed x-rays and molded examples of periodontal disease of the teeth. This photograph is dated September 5, 1932.

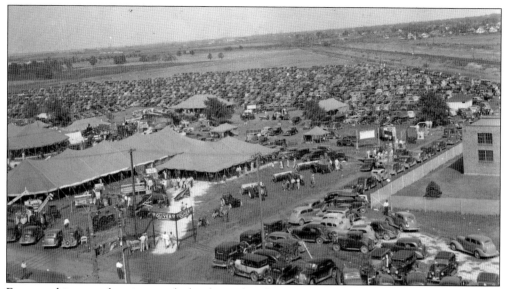

Farm machinery and equipment dealers have played an important part in the Nebraska State Fair from the very first years. As an innovative and progressive agricultural state, Nebraska wanted to promote its products. Large areas were reserved for farm implements, tractors, and planting and harvesting machinery, as well as demonstrations of that equipment. The old photograph above shows the packed parking areas around the farm exhibits. The demonstrations continued to draw crowds, as seen in the 1946 photograph below. The tractor operator demonstrates how he could control the cables connected on the hay stacker so that the loose hay was pushed off the teeth and onto the stack. (Both, courtesy of *Nebraska Farmer Magazine*.)

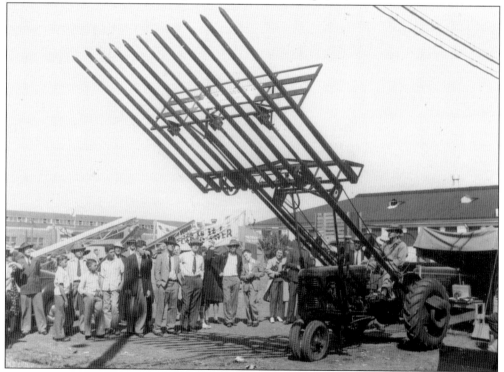

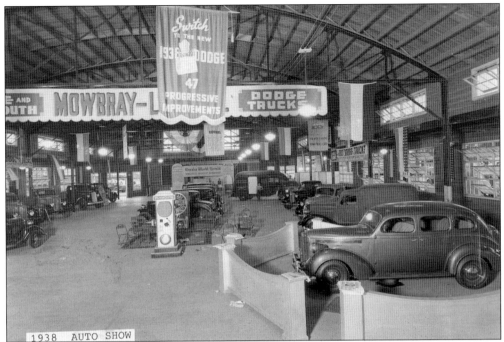

Mowbray–?, a Dodge and Plymouth automobile dealership, set up a huge showroom of the latest car and truck models at the fair in 1938. On the far wall, the *Omaha World Herald* banner boasts that it is "Nebraska's Greatest Newspaper," and a sign on the right offers fair visitors a free souvenir photograph of themselves.

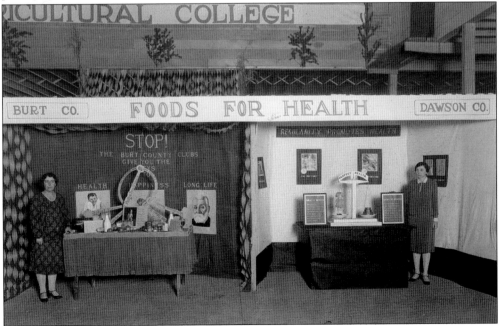

Ladies from Burt and Dawson Counties in Nebraska do their part to promote foods for a healthy body in 1928. Their booths are designed to show samples of foods and habits of eating regular meals for health, happiness, and a long life.

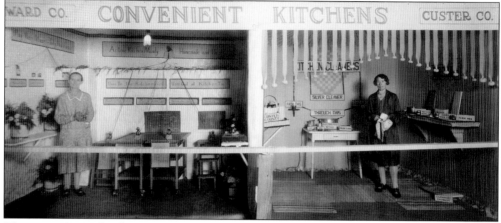

These two 1928 Nebraska County Club members from Seward and Custer Counties share a banner for Convenient Kitchens. The Seward County resident on the left has Mandy dolls pointing at hints for using wheeled tables or step stools to aid the homemaker in the kitchen. The lady on the right demonstrates using kitchen cleaners for silver and wood, as well as wax for the floors.

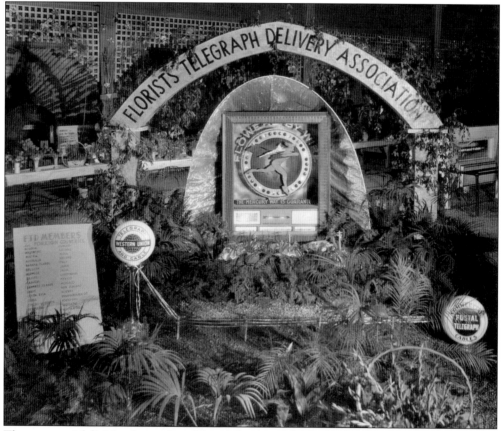

The commercial division featured an elaborate botanical display by the Florists' Telegraph Delivery Association. Western Union Telegraph and Cable guaranteed flowers by wire. Commercial cables for postal telegraphs were advertised on a sign to the right. On the left, a sign lists all the foreign countries with FTD members.

Three

ANIMALS AT THE FAIR

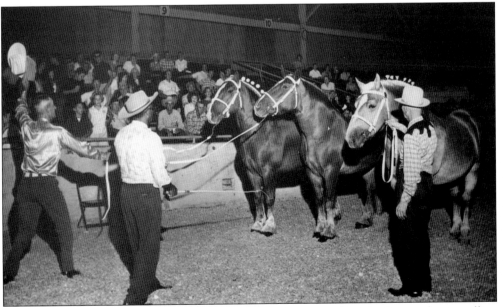

Draft horses are always crowd-pleasers, whether in the ring, marching in the parades, or pulling weight sleds in competition. These gentle giants drew wagons and plows for pioneers long before there were state fairs. Their powerful bodies and the dressing in their manes and tails aid judges in deciding which proud owner of the breed will win the top prize in the show ring.

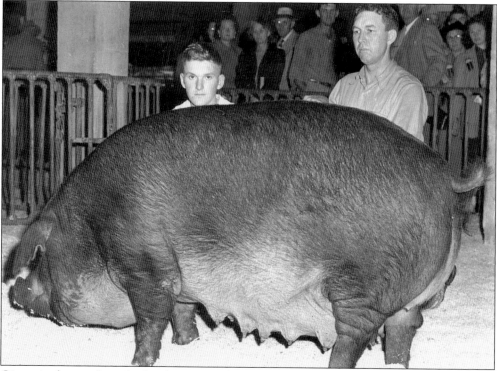

Giant-sized animals—whether horses, cattle, or swine—draw big audiences every year. This heavyweight sow is being shown by a couple of unidentified young gentlemen in the mid-1900s. In the background, the interested onlookers press against the fenced barrier to get a better view. (Courtesy of *Nebraska Farmer Magazine*.)

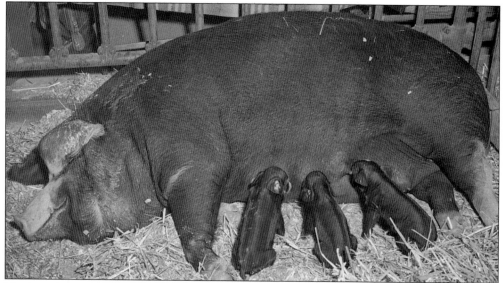

Newborn litters are another exciting exhibit for young and old alike. This Poland China sow is content to lay quietly and let her piglets get their fill. Many swine litters are made up of more than three piglets, but any number will draw oohs and aahs from everyone who sees them. (Courtesy of *Nebraska Farmer Magazine*.)

Farms were often the homes of geese, ducks, and all manner of fowl. They were raised for feathers, meat, and eggs. This proud white goose has been chosen as the best gander in 1968. Ganders are the mature males of the goose family. Goose offspring are called goslings. (Courtesy of *Nebraska Farmer Magazine*.)

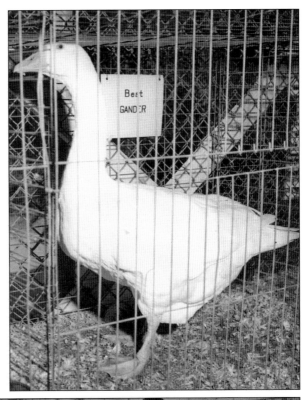

The champion of the ring will often reap additional monetary rewards, which Mike Steckel (far right) can attest to when he received a $100 savings bond for taking home the Grand Champion Hereford prize at the 1964 Nebraska State Fair. Exhibitors usually come prepared, as did Mike, who had a handy currycomb in his front pocket should he need to smooth any stray hairs of the animal's coat. (Courtesy of *Nebraska Farmer Magazine*.)

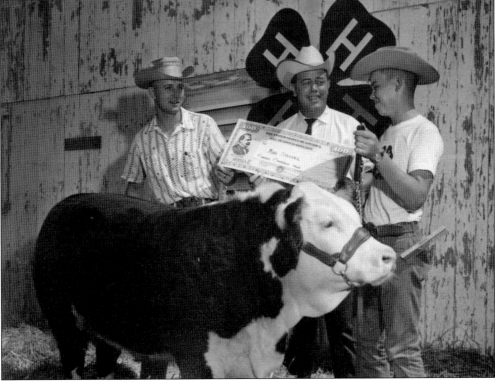

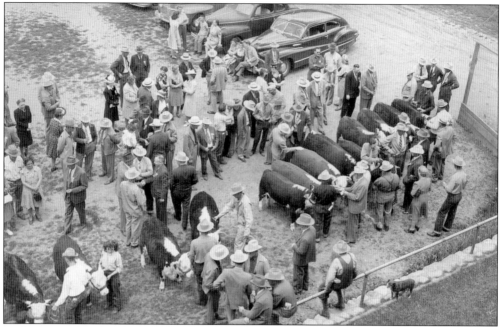

In the late 1940s, the beef judging took place in an outdoor show ring. On the center right side, the judges can be seen with their hands on the two of the Herefords in the competition. To their left, a man is using a currycomb to touch up his animal's appearance for the judges. (Courtesy of *Nebraska Farmer Magazine*.)

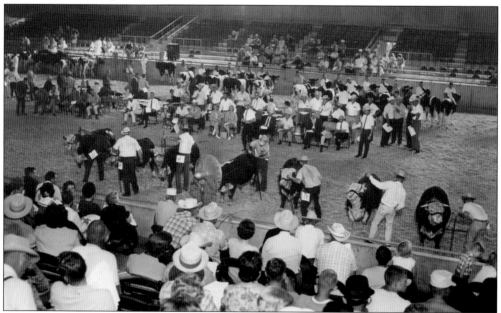

In the mid-1900s, the beef and dairy judging moved to the indoor arena, and the competition for Hereford bulls was held on the near side of the arena. The bulls have rings in their noses, as well as halters, to help control them. Across the arena, on the far side, are dairy animals. One cow even has a small calf at her side. The judges and other spectators are seated in the center of the two simultaneous contests. (Courtesy of *Nebraska Farmer Magazine*.)

A young cowgirl holds her horse close as she brushes its head and mane. The name "Keefer" is on a white sign tacked to the board by the horse's muzzle. (Courtesy of *Nebraska Farmer Magazine*.)

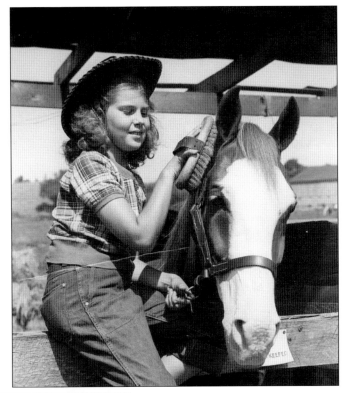

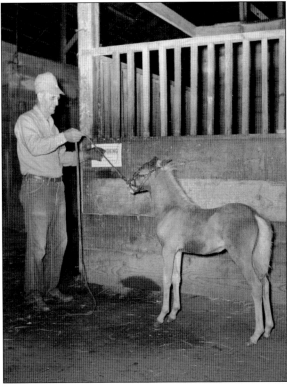

In this 1970s photograph, an unidentified man is working with his young foal outside the stable pen. The foal stands at attention—at least for the moment. (Courtesy of *Nebraska Farmer Magazine*.)

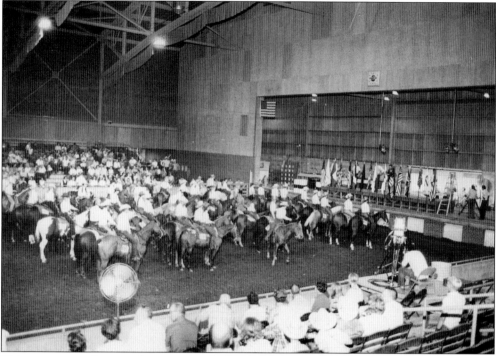

This scene was taken as a large group of riders held their steeds while University of Nebraska horse specialist, Prof. R.B. Warren, delivered a history of the flag, which was followed by the *Star-Spangled Banner*. This took place at the opening ceremony on the final night of the 1970 Nebraska State Fair 4-H horse show. (Courtesy of *Nebraska Farmer Magazine*.)

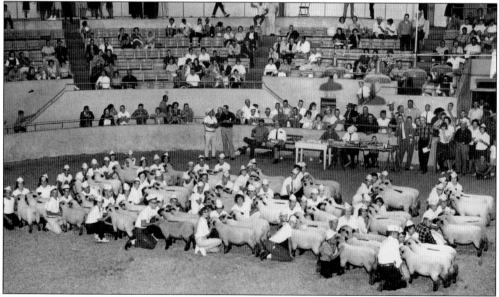

The 4-H sheep competition finds the boys and girls kneeling at the head of their sheep. They line up in closely packed rows in front of the judges' tables on the far side of the arena. An announcer stands with a microphone to deliver the results. All contestants wear 4-H hats, and most wear jeans and white shirts inside the ring. (Courtesy of *Nebraska Farmer Magazine*.)

Four

THE STATE FAIR FOR YOUNG AND OLD

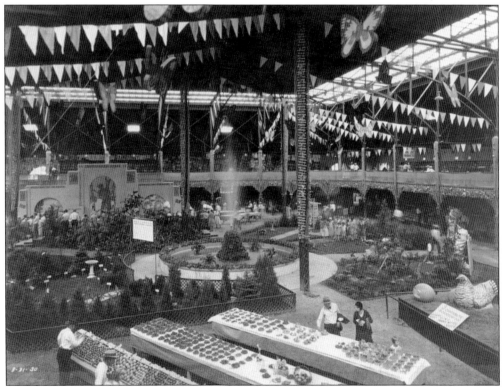

In August 1930, state fair visitors view the horticulture display of plants and produce on the main floor of the Exposition Hall. On the second level, fine arts are on display. A large backdrop facade portrays a farmer in the cornfield and the headline "Cornhusker State." The side panels promote Nebraska's beauty and productivity as an agricultural state.

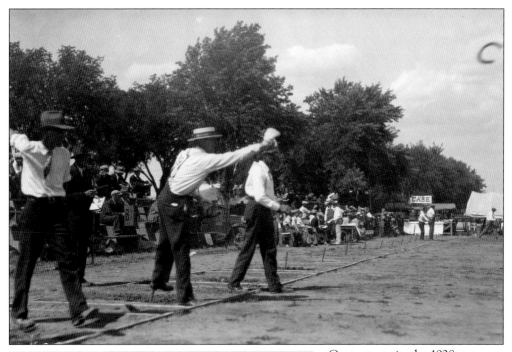

Contestants in the 1928 state fair horseshoe competition entertain the crowd sitting behind them on bleachers. The judge and scorekeeper keep track of the points on a paper pad.

At left is an unidentified participant in the 1930 horseshoe competition. He holds one of his horseshoes in his prosthetic left hand.

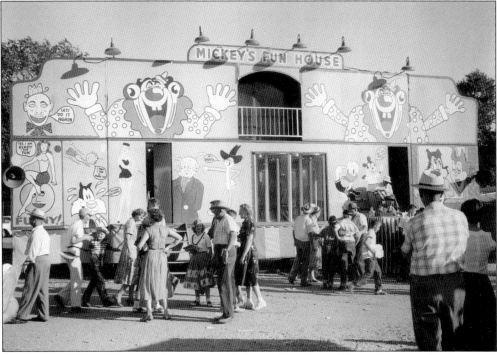

A hawker and ticket seller sit by the entrance of Mickey's Fun House. The wall is covered with cartoon characters, inviting children and grown-ups alike to visit the fun-filled amusements inside.

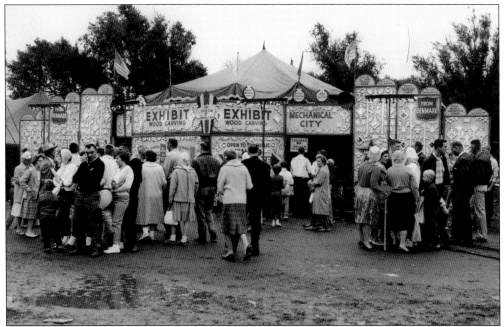

The late-1950s state fair had a wood-carving exhibit from Denmark reportedly worth $100,000. The damp, cool weather did not appear to dampen the crowd's curiosity for the fair's offerings as they walked the muddy thoroughfare. Tickets to enter the exhibit cost 10¢ for children, and adults could "give what they wish" to enter and see the Mechanical City operate the hand-carved display.

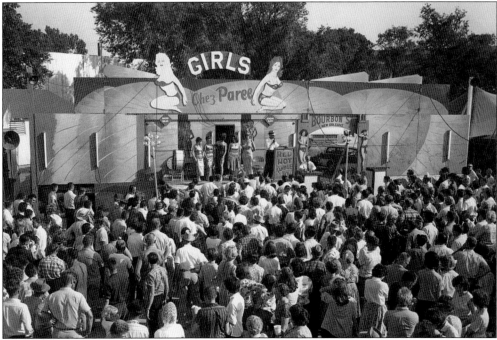

Those in the crowd who were so inclined could visit the Chez Paree Girlie Tent. Five of the pretty girls enticed a look from the young men at the front of the stage with some low-cut gowns and bare legs. Theses shows were abandoned in later years by a vote of the fair board.

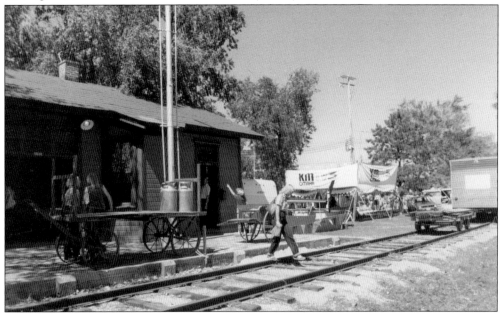

In 1983, the Heritage Village displayed a railroad depot with a short stretch of tracks out front. A cart holding cream cans sits near the tracks to represent one of the products hauled by rail to market in the past. The preservation of state history was considered an important venue to be developed and maintained at the fair, leading to the addition of a rural schoolhouse and other historical exhibits.

This is a full-size replica of a windmill erected in Heritage Village. Windmills dotted the landscape of Nebraska to provide water for household use, as well as pumping water to fill tanks for livestock in rural areas. The wet platform hosts a working hydrant as part of the display.

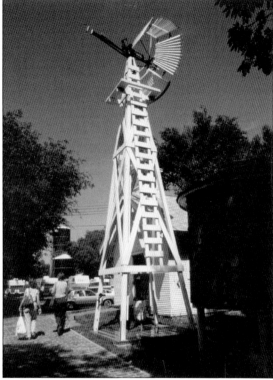

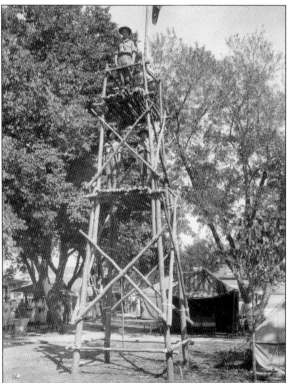

The Boys Scouts of America built a tower with two levels in the 1940s and 1950s. The legs and cross ties are formed from cut and trimmed tree trunks secured with ropes. Boy Scouts occupy the platforms on each level as they watch over the tents and visitors below. An American flag flies above the platform.

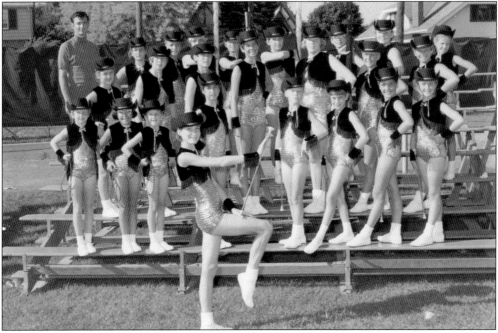

Above, a baton-twirling troop poses with their instructor or sponsor on tiered bleachers. Three young participants hold jump ropes, probably used in their performance, and all wear identical glitzy uniforms with white bobby socks, white shoes, fringed black vests, and cowgirl hats.

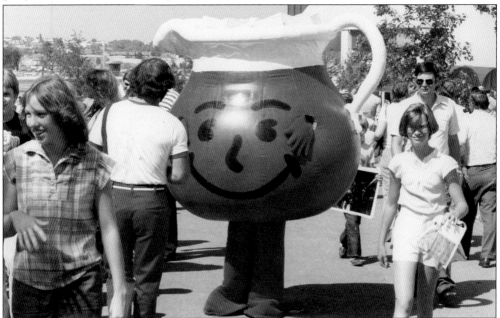

Kool-Aid Man, first called Pitcher Man, walks the fairgrounds in the 1970s and greets everyone with a wide smile and a handshake. Kool-Aid originated in Hastings, Nebraska, in 1927. Edwin Perkins took the liquid form of Fruit Smacks, made a powdered mix in six flavored drinks, and called it Kool Ade. Later, the name was changed to Kool-Aid. This costume is now on display in the museum at Hastings.

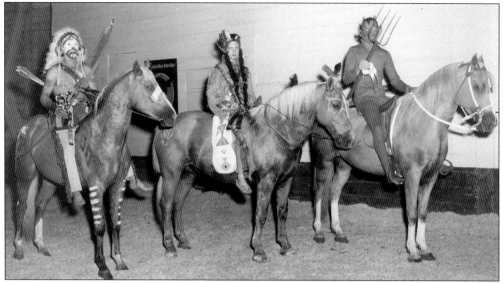

In this 1952 image, contestants hold award ribbons while the rider on the left also displays his trophy. He is in Indian costume with war paint on his face and horse, which he rides bareback. The young Indian maiden has a decorated leather jacket, leggings, and moccasins. She also sits bareback on a painted horse. The third rider uses a saddle, wears devil's attire, and brandishes a pitchfork.

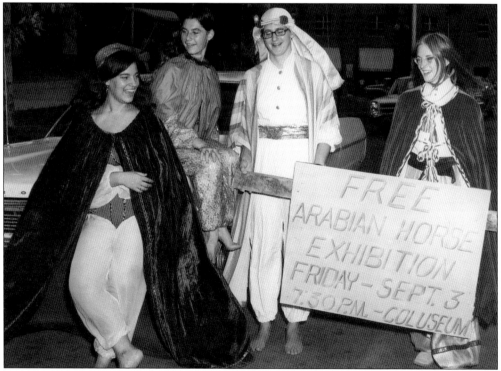

Four youths help advertise the 1971 free Arabian horse exhibition in the coliseum on September 3, a Friday night during the state fair. They wear Arabian costumes of cloaks and headpieces—three are barefoot—as they display a sign for prospective onlookers.

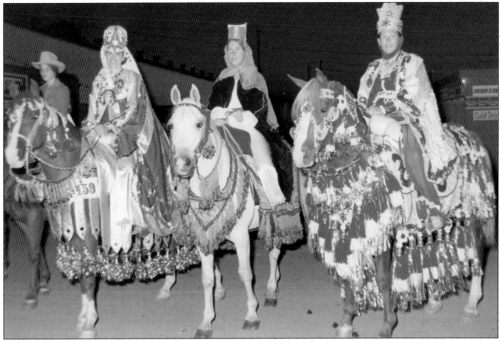

Four contenders dressed in full regalia are vying for the highest award of best Arabian attire for horse and rider. They pause for a photograph as they prepare to enter the show ring in the coliseum. This is the exhibition that was advertised in the previous photograph.

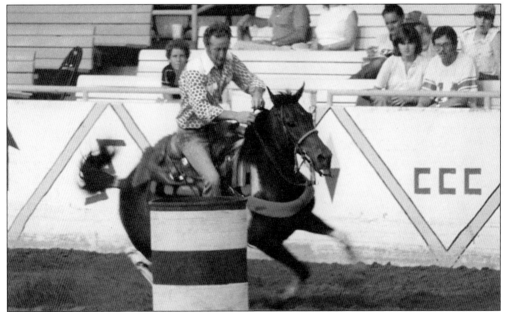

Barrel racing is a timed rodeo event. The combined expertise of the horse and rider is needed to complete the cloverleaf course in the fastest time possible to win. They must follow a prescribed route around three barrels in the arena without hitting or knocking them over. The stopwatch runs from when the horse and rider cross the start line into the arena until they cross the finish line with a speedy exit.

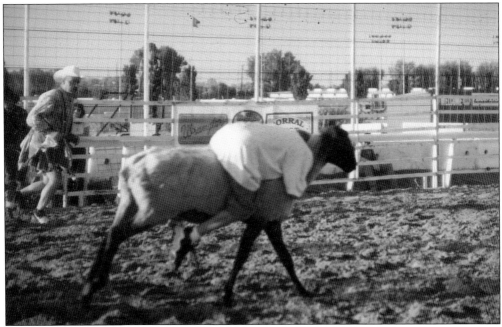

This 1997 photograph captured a popular event for little rodeo hopefuls—the Mutton Bustin' contest for kids. The rodeo bullfighter keeps a close eye on this determined rider who has wrapped himself into a stranglehold on the racing sheep. Whoever hangs on the longest is the winner of this crowd-pleasing competition.

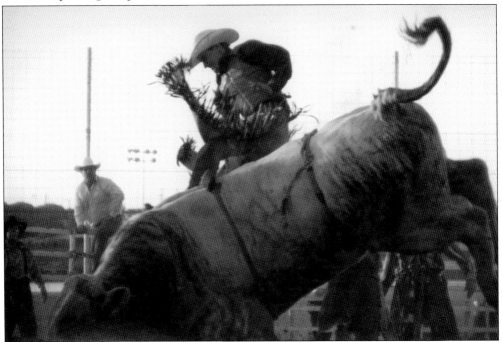

Another entertaining rodeo event is that of the grown-up bull riders. This bull rider still has his hat after getting bucked off. Two rodeo bullfighters standing ready for the rescue can be seen beyond the bull's upraised rump.

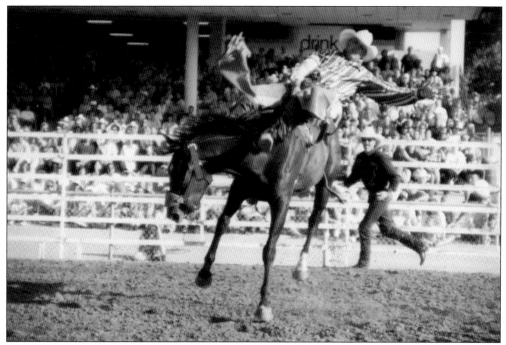

The grandstand is filled with rodeo lovers as the Bareback Bronc rider's legs and left arm flail in his attempt to stay on for the whistle at the end of the eight-second ride. Both rider and mount earn points in the competition.

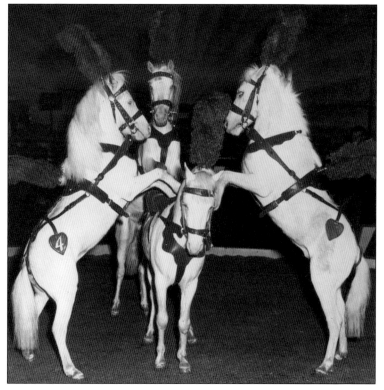

Everybody loves a circus, and the Nebraska State Fair Board decided that a variety of circus acts would help increase attendance numbers in the 1950s. Seen at left, four white horses perform their act without a rider holding the reins.

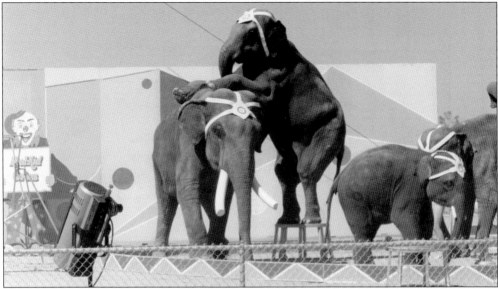

What is a circus without elephants? One precariously balances on its hind legs while on a small platform. The clown display to the left holds a sign indicating this is the Kool-Aid Circus.

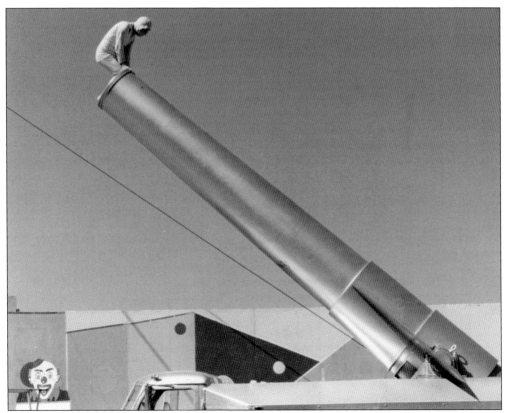

The cannon man enters the barrel for his shot to be heard across the fairgrounds. He performed as part of the acts in front of the grandstand audience in 1978.

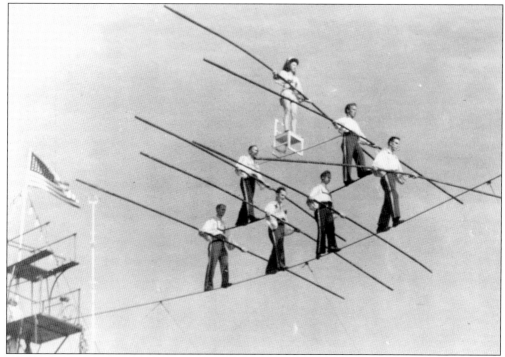

This high-wire act has six men balancing with long poles. The two men on the second tier stand on poles suspended from harnesses on the shoulders of the men below. A woman stands on the seat of a chair, balanced with her long pole on the pyramid's peak.

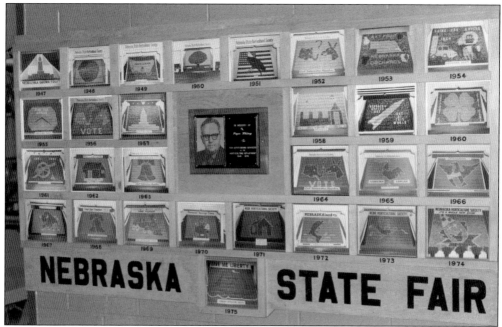

A wall of Nebraska State Fair photographs depicts the designs made of apples exhibited from 1947 through 1975. A memorial plaque and photograph honor Wayne Whitney for outstanding services in the horticultural department from 1948 to 1976.

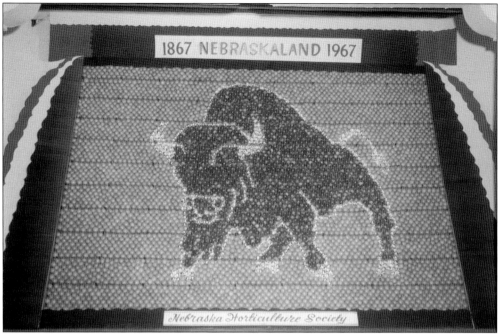

This is a close-up view of the 1967 apple display designed by the Nebraska Horticultural Society. This one portrays the American bison as it represents the Nebraskaland Centennial from 1867 to 1967.

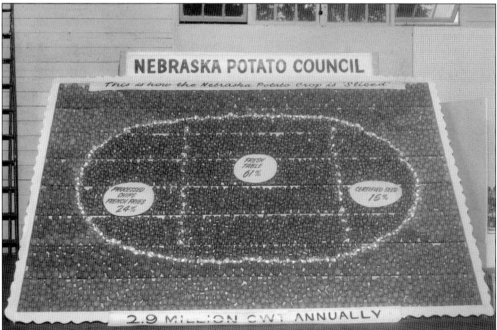

The Nebraska Potato Council display made of potatoes shows the percentage of potatoes used for processed chips: 24 percent; fresh table: 61 percent; and certified seed: 15 percent. The banner at the top says "This is how the Nebraska Potato Crop is 'Sliced.'" Beneath the arrangement of potatoes, the caption reads "2.9 MILLION CWT [hundredweight] ANNUALLY." This exhibit was in the old Agricultural Hall during the 1950s.

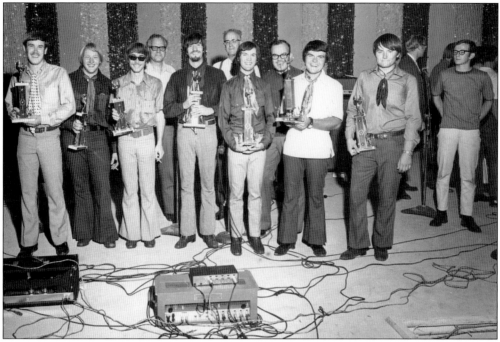

Trophy winners in the 1969 Battle of the Bands gather on stage to receive their awards. Neck scarves and bell-bottom trousers were in fashion at the time.

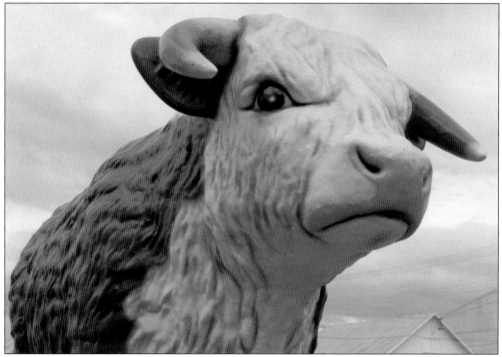

A large statue of a Hereford bull was brought in to stand near the livestock barns in 1970. The Hereford breed was prominent early on in the livestock arena. The first three Herefords were imported into the United States by Henry Clay in 1817. Hereford cattle are of British origin.

Five

THE MARVELOUS MIDWAY

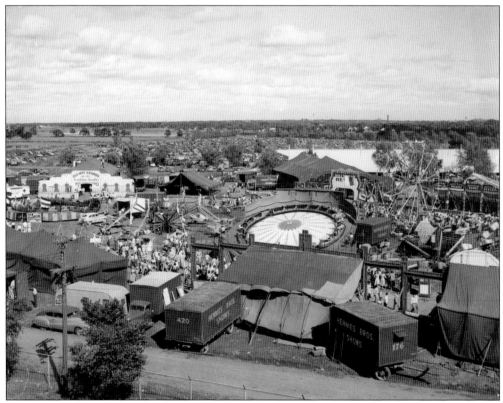

Hennies Bros. Shows brought the midway tents and rides to the Nebraska State Fair in the 1950s. The typical rides to the right are the Ferris wheel, the Octopus, and a big circular bullet-nosed train ride gracing the middle area. To the left of the train are the Fly-O-Plane ride and the Little Dipper roller coaster. To the left of those, a ride called the Caterpillar is set up near a medical education trailer. Mrs. Grundy's Scandalous Beauties tent is prominently displayed with large white frontage.

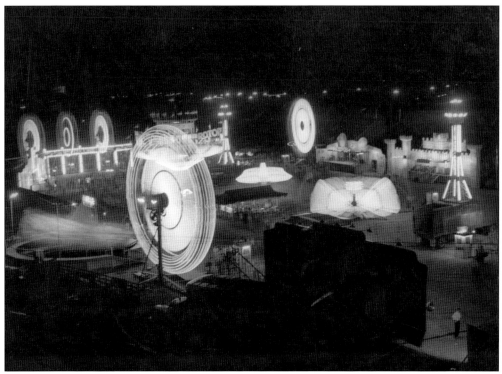

A nighttime photograph of this 1940s midway lends a magical spin to the lights of the rides and vendor booths.

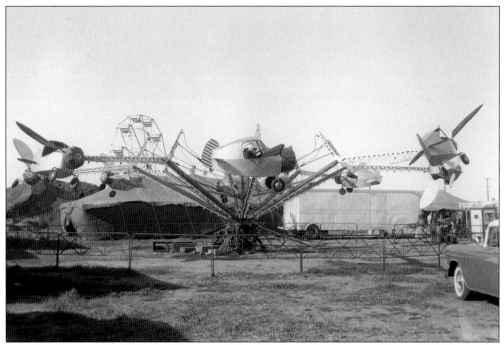

In the image above, fairgoers enjoy the Fly-O-Plane sometime during the 1950s. Spectators stand near the entrance to watch it lift and circle, while ticket holders wait for their turn at the throttle.

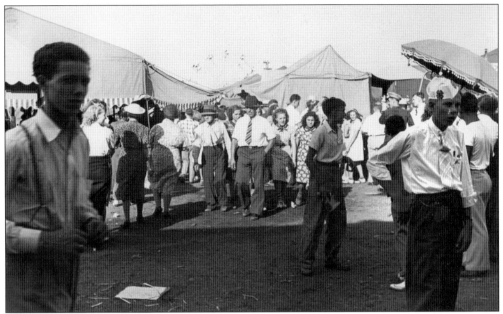

Fairgoers mingle, meet, and pass while they check out the vendor tents in the mid-1950s. Men wear hats, suits, pants, and ties. Ladies and girls wear mainly floral-print dresses and hats in this photograph. The younger generation enjoys the fashionable saddle shoes and multi-patterned socks. To the right, a young lad wears his 4-H exhibitor hat and the acceptable attire of white shirt, tie, and dress slacks.

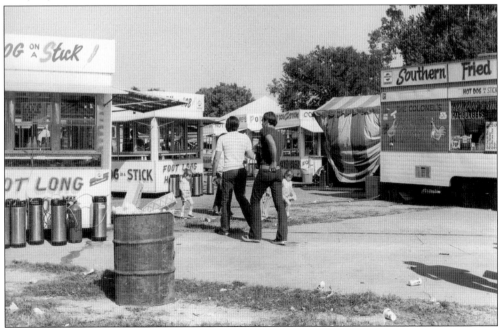

Food vendor stands line both sides of the path through the midway in 1971. Four of the vendors advertise foot-long hot dogs, foot-longs on a stick, hot dogs, or hot dogs on a stick. The Colonel's Southern Fried Chicken stand, a forerunner to the Colonel's Kentucky Fried Chicken conglomerate, also offers hot dogs on a stick and hamburgers for sale at the window to the right.

A close-up shot of a 1970s bumper car reveals a sturdy chassis and padded seat to protect the rider who climbs in to race in a circle and safely bump other drivers out of the way.

The Super Loop incorporates the movement of centrifugal force to flattens the riders' backs against the wall as they stand in a cage to experience the thrill of the dizzying ride. The other carnival rides visible are the Twister and the Ferris wheel.

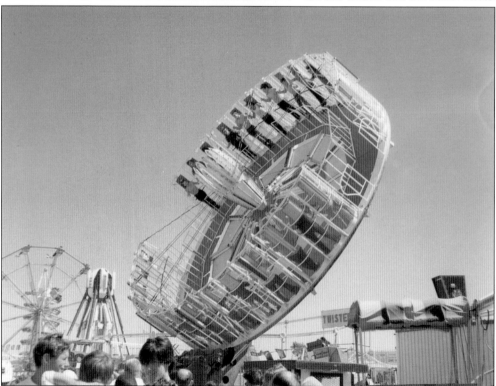

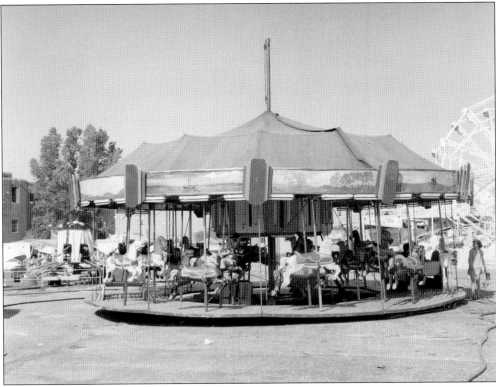

Small children and their parents often head toward the carousel at the Nebraska State Fair. Although the little ones may be too timid to ride a live pony, they usually will enjoy a galloping ride on a merry-go-round steed. Those who are young at heart may still enjoy the band organ music and a slow whirl on the benches.

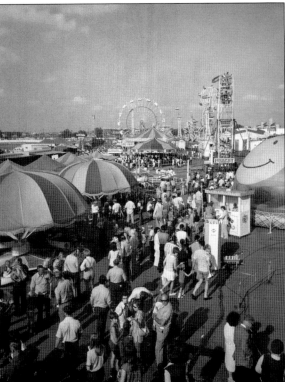

The Murphy Brothers midway draws a stream of patrons steadily flowing between the rides and tents to form a line for tickets at one of the 1970s fairs. A huge, inflatable smiley face welcomes everyone, and there are two different Ferris wheels, plus a double Ferris wheel visible in the center and right side. In the far distance, the supporting framework for the Zyklon roller coaster surges and dips on the horizon.

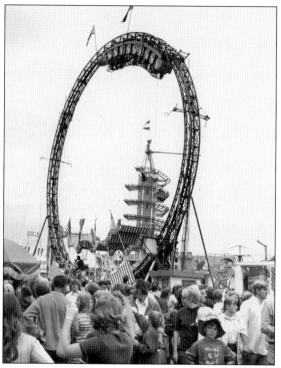

All seats are filled on the Ring of Fire as it traverses the large hoop. The cars hang upside down at the top and are no less scary as they speed down to the bottom. The Toboggan spiral is seen framed in the hoop for those who want a fast ride without hanging inverted in midair. The photograph below is a close-up of the Toboggan tower. The Toboggan car spirals down the track while the midway crowd watches the activities surrounding them. A few, more adventurous rides can be seen in the background.

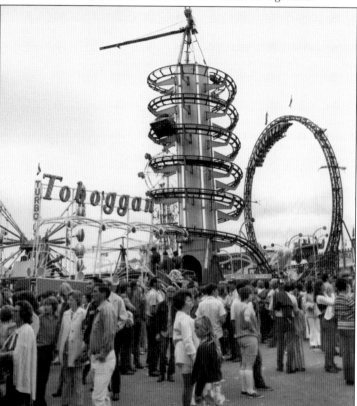

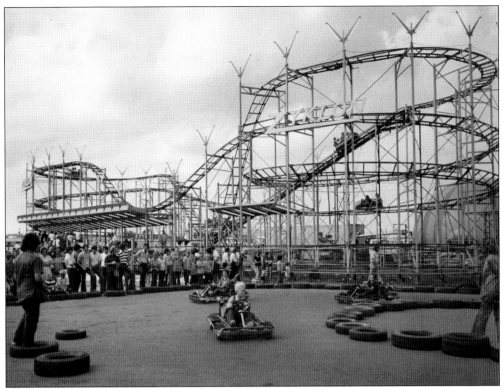

The Zyklon roller coaster has four cars running on the tracks simultaneously as one pulls up to the finishing gate. There is standing room on the entrance ramp for ticket holders. In the foreground, three go-cart drivers race around the curves of the track inside the rubber-tire perimeter.

The huge crowd just keeps coming as people move forward to pass the Murphy Brothers Exposition entrance towers. The towers entice customers with the descriptive words painted high and large enough to be seen from blocks away. These words promise the pathway leads to the "Mile Long–Pleasure–Trail." On the midway, lines form at the chocolate nut sundae and cotton-candy stands.

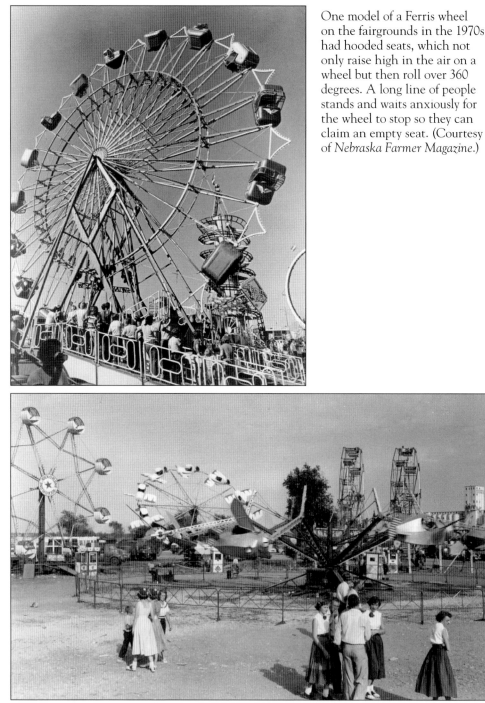

One model of a Ferris wheel on the fairgrounds in the 1970s had hooded seats, which not only raise high in the air on a wheel but then roll over 360 degrees. A long line of people stands and waits anxiously for the wheel to stop so they can claim an empty seat. (Courtesy of *Nebraska Farmer Magazine*.)

A scarce number of prospective customers have airplane rides to choose from during the mid-1900s. There is a wingless Rock-O-Plane on the left and the familiar Fly-O-Plane on the right. A double side-by-side Ferris wheel boasts at least four customers. Beanie hats, black-and-white saddle shoes, longer full skirts, and white sleeveless blouses with flowers at the neckline seem to be popular with this group of teens. (Courtesy of *Nebraska Farmer Magazine*.)

Six

PRIDE OF NEBRASKA

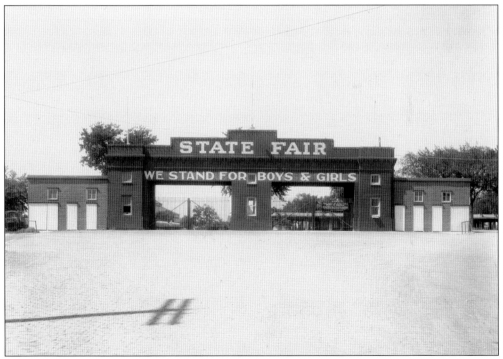

In 1926, the words "WE STAND FOR BOYS AND GIRLS" grace the front gate marquee. Boys and Girls Clubs were formed in 1902 by A.B. Graham in Ohio. These clubs developed and evolved into the establishment of 4-H clubs in nearly all states from 1905 to 1914. The national Future Farmers of America formed groups starting in 1928. Members of these two groups showed livestock and exhibited their projects at local and state fairs.

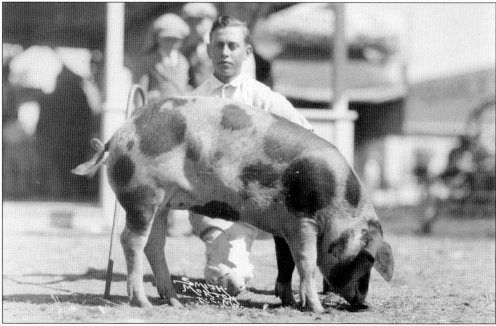

Anthony Poporny of Waverly, Nebraska, received the Best Showman in Club award for pigs with his spotted swine during the 1928 state fair.

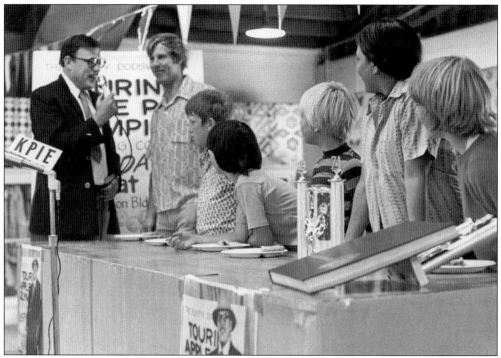

Hungry participants listen intently to the instructions for a pie-eating contest in 1974. Radio station KPIE has drawn five young male contestants who look anxious to begin the feast. The champion's trophy sits on the counter to the right, and the competitors' first piece of pie waits on the plates.

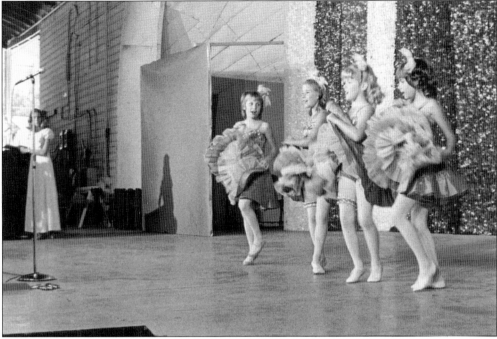

Talent contests held at the county fairs send the top performer to state competition. Here, four youthful dancers do their rendition of a cancan number. They flash ruffled skirts, cancan slips, and fancy garters worn on their right thighs.

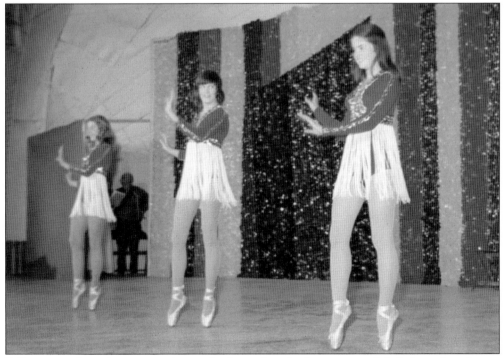

Ballerinas perform their routine in a perfectly synchronized movement while balanced on tiptoes. They are on the open-air auditorium stage for their presentation in 1974.

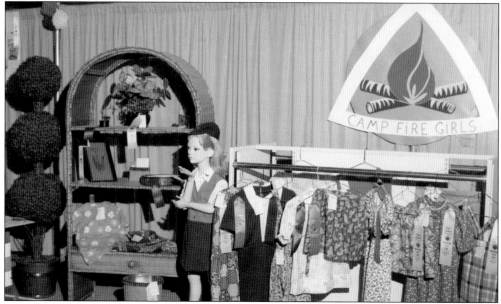

The Camp Fire Girls decorated a booth featuring a mannequin in uniform as part of the display. Many of their sewing projects have received ribbons, which are tied prominently for visitors to see. A variety of other handiwork is presented on the shelves to the left.

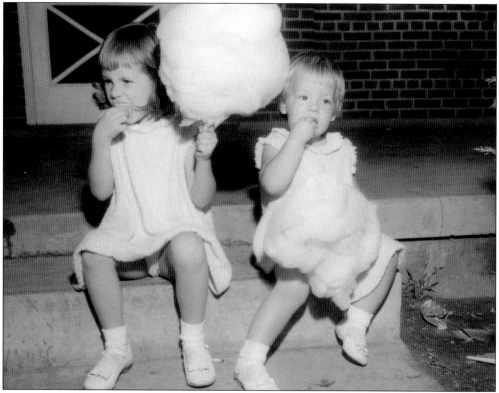

Two small girls enjoy the sticky treat of giant cotton-candy puffs while sitting on the steps of the Lancaster County Post Office building at a 1960s state fair.

With her wide dark eyes and a smile that spreads from ear to ear, it is easy to see how delighted this little girl is with her ride on a live pony. The state fair offers special rides and events for kids year after year.

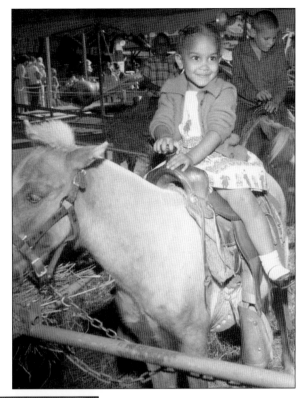

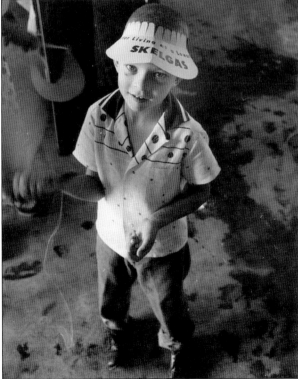

Six-year-old Stephen Frerichs of Cortland, Nebraska, shows off his brand-new hat after a visit to the Skelgas vendor booth. This photograph is dated from the 1960s.

David Hilgenkamp, age 13, of Colon, Nebraska, received the 1968 champion Hampshire market lamb ribbon in the 4-H division. He is the son of Mr. and Mrs. Leslie Hilgenkamp. (Courtesy of *Nebraska Farmer Magazine*.)

The top showmanship honors were given to Ronny Morgan, left, of Burwell. He took home the gold medal with his Angus named "Chris" in the state fair 4-H beef show. Ronny, son of Mr. and Mrs. Dan Morgan, was also presented a Hereford calf as a part of his winnings. Chris Lovejoy (right, holding rope), of the Lovejoy Ranch near Valentine, is seen presenting the calf to Ronny. (Courtesy of *Nebraska Farmer Magazine*.)

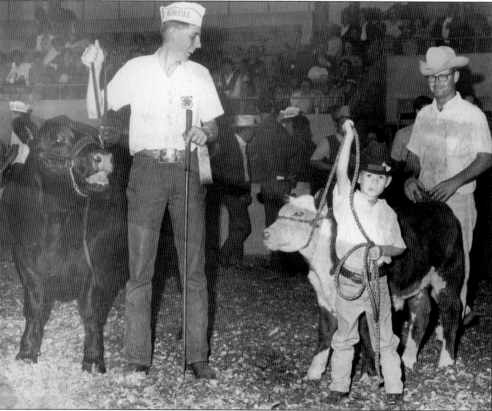

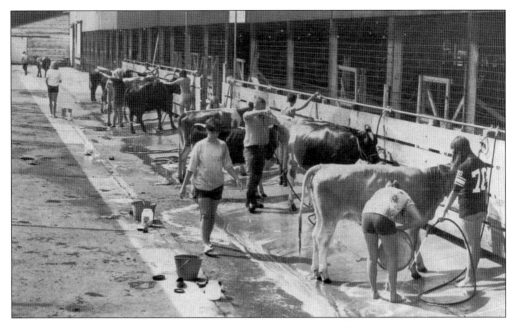

A big part of the requirements for 4-H members is to be responsible for record keeping, attending meetings, and completing all projects. Winners in county fairs qualify to show their projects and have them judged at the state fair with the winners from the other 92 counties in Nebraska. When the animals are prepared for the arena, part of the grooming takes place at the wash racks provided outside the livestock barns. In these two views of the careful cleansing, hopeful exhibitors make their dairy animals look their very best in hope of receiving a purple ribbon. Top winners get to compete for the championship trophy. (Both, courtesy of *Nebraska Farmer Magazine*.)

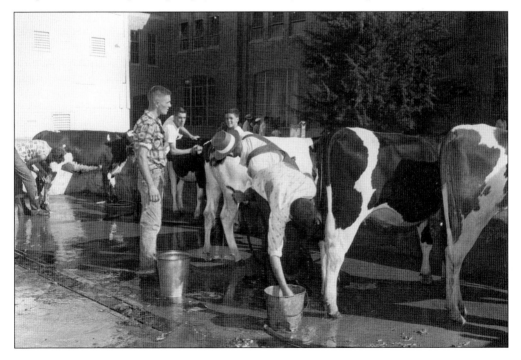

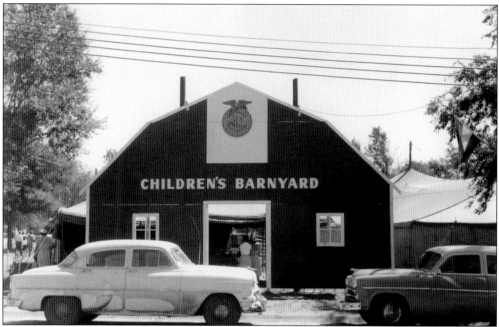

This photograph of the Children's Barnyard exhibit barn displays the national FFA emblem on the peak of the building. This view of the barn was taken in the 1950s. The Children's Barnyard was replaced by a restaurant with 40 tables in 1973. A new building constructed by Farmland Industries opened in 1975. (Courtesy of *Nebraska Farmer Magazine*.)

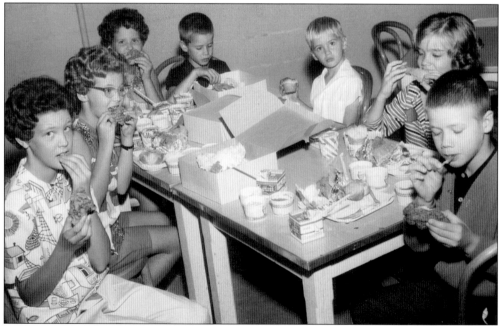

Everyone gets hungry at the fair. In the late 1950s, box lunches were sold at the fair. This group of children gathers around a table in the basement of the Administration Building to devour their Kentucky Fried Chicken, which is accompanied by small paper cups filled with the vegetables or potatoes, a carton of milk, and a small cup of ice cream served with a flat wooden spoon.

These two young 4-Hers have won the distinction of being chosen as 1928's 4-H health boy and 4-H health girl. Much like the healthy baby competition, good eating habits and good hygiene were stressed in organized club activities for young people.

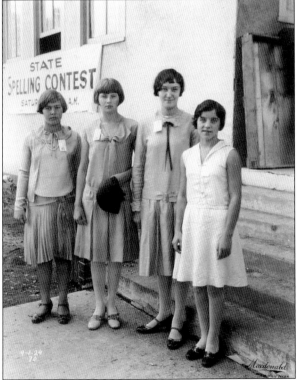

The top four winners pose outside the building that held the state spelling bee competition. The spelling contest held in the 1920s included the champion speller from every county in the state. These four made it through all the elimination rounds without error to come out on top.

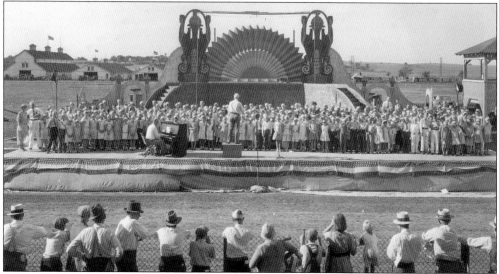

September 6, 1931, is the day of the schoolchildren's mass choral recital. This large group performed on stage in front of an audience of proud parents and onlookers. They all dressed in their Sunday best, and all are wearing white headbands for the big event.

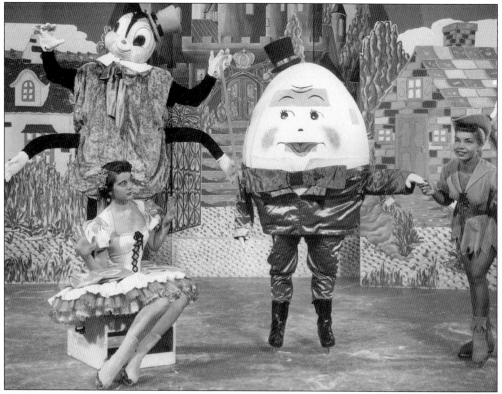

Children are performers in the *Storybook Village* featured on ice at the fair. This grandstand attraction took place in 1957 and was sold out. The spectacular stage props and costumes were enthralling to young and old alike. Several acts, such as "Candyland" and "Merry Widow," were presented, as well as other performances of *Storybook Village* characters.

The two little boys have found a small Angus calf just their size. They hold the little critter by a length of twine around its neck. The little guys look comfortably dressed in their Big Mac bib overalls and baseball caps.

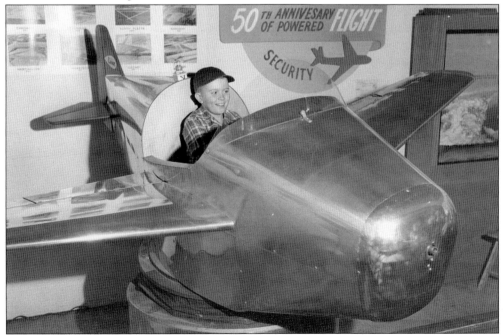

This young boy celebrates the advertised 50th Anniversary of Powered Flight by climbing into the cockpit of the display plane. The anniversary date was celebrated in 1953 in honor of the Wright brothers' first flight, which they made on December 17, 1903, in North Carolina.

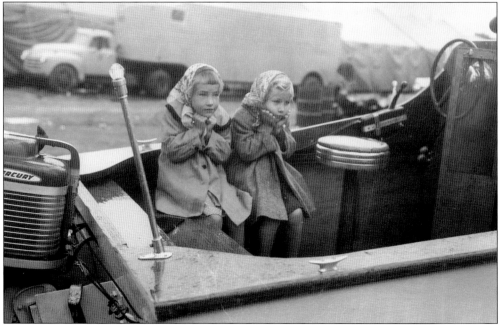

Not every state fair was held in warm weather at the end of August or first of September. Two little girls sit shivering in the back of a boat parked on the state fairgrounds in the 1950s. They wear long coats and scarves on their heads, but they do not appear to be enjoying themselves much at the time this picture was snapped.

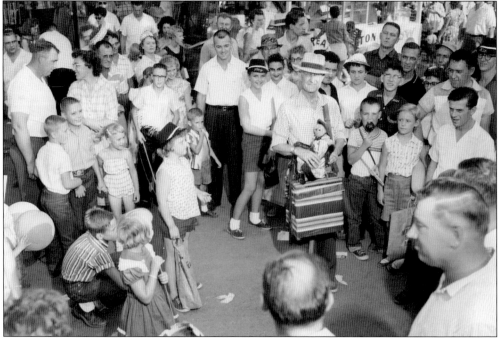

A man and his pet monkey entertain a gathering on the fairgrounds. The children's faces express a range of emotion as they watch. Some have smiles, while others look a little apprehensive, and none approach the little monkey too closely.

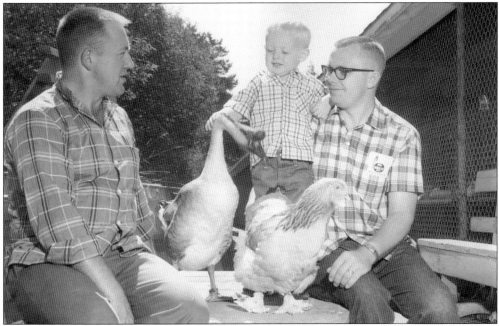

Two unidentified men introduce a young lad to a goose and a chicken outside the poultry barn at the state fair in the mid-1960s. These two fowl entries sport some unusual characteristics, such as feathers on the chicken's feet and a large knob above the goose's beak. The knob is typically found on an African goose or Chinese goose. Several breeds of chickens have feathered feet.

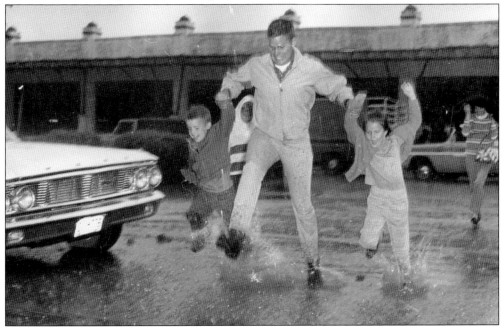

A father joins hands with his two young children to jump over puddles in the rain. This picture is dated 1968, but in 1989, there was a total of 10.3 inches of rainfall, with 7 inches accumulating on the second Friday of the fair. However, it did not stop the attendance of dedicated fairgoers. A total of 594,064 patrons braved the wet conditions.

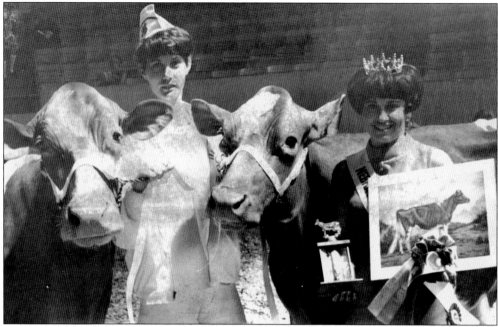

Judy Wiechert of Lincoln took home double honors at the 4-H dairy show in 1968. "Faith and Fairy," a mother and daughter bovine combo, gathered ribbons and trophies for champion and reserve champion Guernsey breed of dairy cows. The Nebraska Dairy Princess Deanna Bond (right) of Avoca, Nebraska, presents the awards. (Courtesy of *Nebraska Farmer Magazine*.)

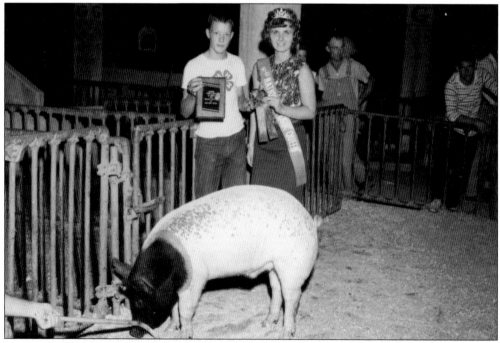

Tommy McKay from Roca, Nebraska, accepts a championship ribbon and plaque for his pork project. National Pork Queen of 1962–1963, Flavian Goeller of Pilger, Nebraska, presents the prized rosette-adorned ribbon.

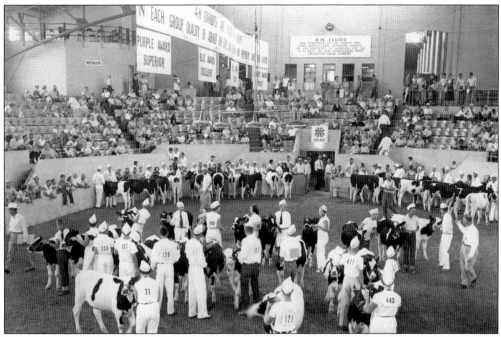

This view shows the 4-H dairy exhibitors with their Holstein entries gathered in the arena to be judged at the state fair. The exhibitors wear numbered identification placards on their backs. The 4-H four-leaf clover symbolizes the head, heart, hands, and health pledge of the nationwide organization. A banner stretched above the spectators explains the degree of ribbon placement, such as purple being superior, blue being excellent, red being good, and white being a merit award. (Courtesy of *Nebraska Farmer Magazine*.)

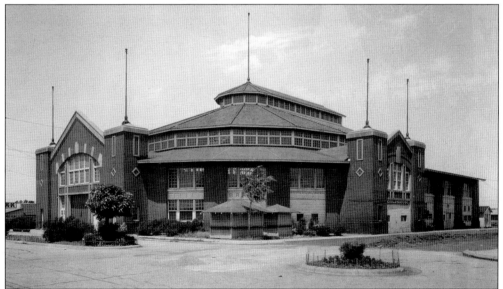

A notation with this image states that this was a new livestock pavilion in 1929, and it indicated it was also the stock-judging pavilion in 1937. The double doors on the right have a sign directing participants into the coliseum. On the left side, there is a second building with "KKK Dining Hall" painted on the roof and sidewall. (Courtesy of *Nebraska Farmer Magazine*.)

The 4-H clubs of Nebraska grew in membership and played a much larger part in the state fair year after year. The building pictured above served its purpose well until it was replaced with a 4-H Youth Complex (below). In 1931, the new 4-H Youth Complex was built at a cost of $150,000, and a note on the photograph claimed it to be "the only building of its kind in the world." The building was dedicated on September 6, 1931. On the front above the entrance is a sign for access to the auditorium in the 4-H Exhibition Building. Another entrance can be seen near the cars parked along the street side of the building. Two vendor stands are on the left side of the photograph below. (Both, courtesy of *Nebraska Farmer Magazine*.)

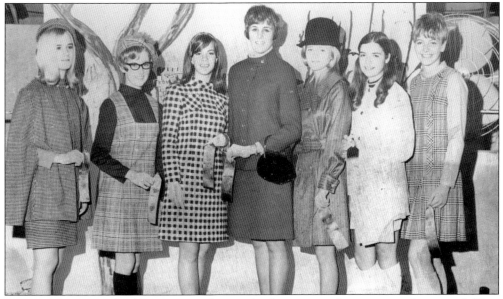

Seven of the 56 purple ribbon winners line up for the camera after receiving their award. They were participants in the 4-H Dress Revue at the Nebraska State Fair in 1968. These fashionably dressed young misses are identified from left to right as Juli Wurtele, Nebraska City; Meredith Clark, Lewiston; Sheryl Ann Vitosh, Odell; Jane Niebrugge, Auburn; Barb McCracken, town unknown; Donna Matthes, Falls City; and Karen Wielage of Beaver Crossing. All of these towns are located in southeastern Nebraska counties. (Courtesy of *Nebraska Farmer Magazine*.)

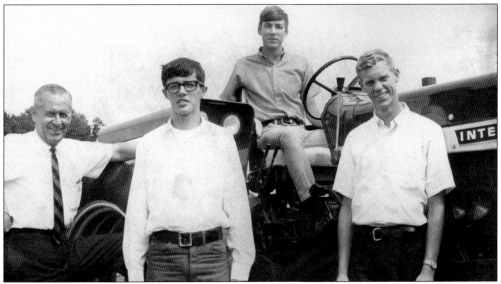

Another 1968 group of youthful winners took home top prizes in the State 4-H Tractor Operators Contest. G. Rude (far left) of Standard Oil presented the awards at the state contest. Rodney Beemer (second from left) of Norfolk placed third. Seated on the tractor is champion James Hilgenkamp, 17, son of Mr. and Mrs. Floyd Hilgenkamp of Arlington. Lewis Barth (far right) of St. Paul took second place. Hilgenkamp qualified to compete in the Western US Regional Tractor Operators Contest sponsored by American Oil Company the following October in Laramie, Wyoming. (Courtesy of *Nebraska Farmer Magazine*.)

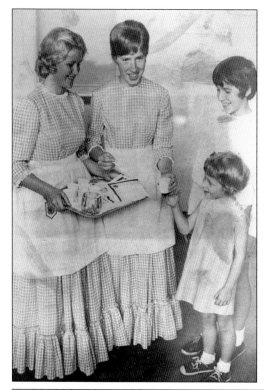

The ice cream food demonstration was presented as one of the projects shared by Sheila Johnson (holding tray) and Margaret York, who came to Lincoln from Mead. They took home a blue ribbon for their efforts of hand turning an ice cream freezer to produce ice cream served with strawberry sauce. The happy taste testers are Margaret's two younger sisters, Jeanne and Patty. (Courtesy of *Nebraska Farmer Magazine*.)

All 4-H members were able to follow a myriad of individual interests in their choice of annual projects. Dawson County 4-Her Janet Libal won an all-expense-paid trip to Chicago when she demonstrated the construction and use of a squeeze chute to safely handle cattle. As a bonus, she received a congratulatory hug and handshake from Nebraska governor Norbert T. Tiemann. (Courtesy of *Nebraska Farmer Magazine*.)

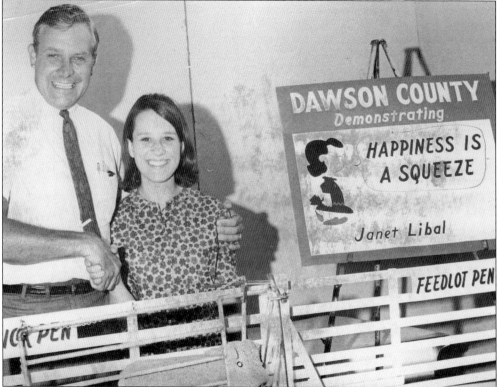

Photography projects have drawn many 4-Hers into taking candid shots of scenery, nature, pets, and everyday surroundings. Robin Phillips of Beaver Crossing holds his collage of a picture story to describe the process used by Houchen Bindery in Utica, Nebraska, to repair and rebind old books and make them like new. He earned a purple ribbon on the photographic series. (Courtesy of *Nebraska Farmer Magazine*.)

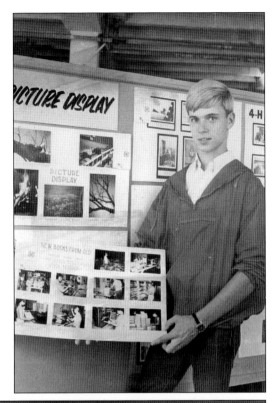

From start to finish, 4-H projects range through the life span, and some prizes are awarded after a carcass is judged. Tim McGuire of Wisner received a trophy from Robert Haines, a representative of the Cooper Feeds in Humboldt. McGuire showed the champion swine carcass during the state fair contest in 1966. (Courtesy of *Nebraska Farmer Magazine*.)

Sara Klemm, the beef carcass winner in the mid-1960s, is seen here looking at her champion meat carcass. She is pictured with Vincent Arthaud, a professor of animal science. The beef was jointly owned by three Klemm sisters: Sara, Sandy, and Susan of Exeter, Nebraska. (Courtesy of *Nebraska Farmer Magazine*.)

The poultry judging team of Cass County won first place in the mid-1960s. These four team members testing chicken eggs are, from left to right, (seated) Susan Glasshoff of Murdock and Marvin Vogler of Louisville; (standing) Russell Glasshoff Jr. and Barbara Zierott, both of Murdock, Nebraska. (Courtesy of *Nebraska Farmer Magazine*.)

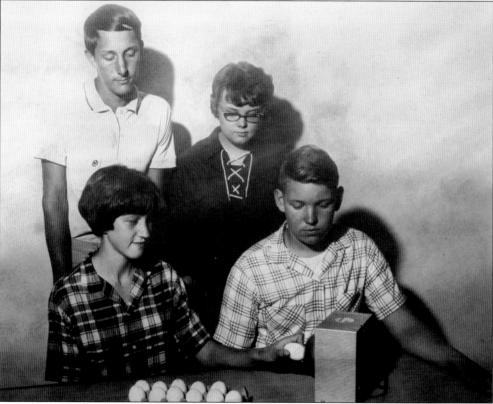

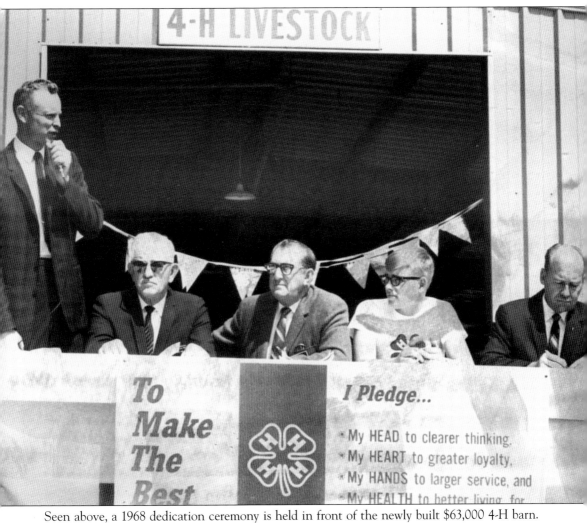

Seen above, a 1968 dedication ceremony is held in front of the newly built $63,000 4-H barn. Dignitaries present at the opening were, from left to right, associate state 4-H leader Ken Schmidt of Lincoln; Don Thompson of McCook, second vice president of the Nebraska Board of Agriculture; Floyd Pohlman of Auburn, president of the board; Bruce Rickertsen, Dawson County 4-H member of Lexington; and Lancaster County extension agent Cyril Bish. The 4-H pledge is prominently displayed in front of the distinguished guests. The pledge every 4-H member memorizes is "I Pledge My Head to clearer thinking, My Heart to greater loyalty, My Hands to larger service and My Health to better living for my club, my community, my country and my world." The 4-H motto is "To Make The Best Better." (Courtesy of *Nebraska Farmer Magazine*.)

Playing cards alleviates the stress of the day for 4-H exhibitors who are camping on the fairgrounds. From left to right sits Lloyd Tiedeman, Agnetta Remter, and Bob Tiedeman (all from Hickman, Nebraska) and Janet Hatcher. A young boy and lady stand near one of the fairground cabins in the background. (Courtesy of *Nebraska Farmer Magazine*.)

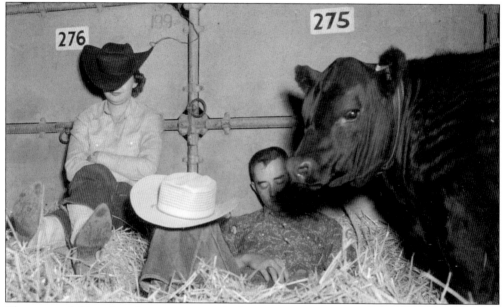

These two exhibitors have been worn out with the anticipation, preparation, anxiety of performance, and end results of the year's work. Their efforts led to the finale of the largest venue in which to show their animal—the Nebraska State Fair. A quick siesta can rejuvenate the energy, and they will be ready for things to come. (Courtesy of *Nebraska Farmer Magazine*.)

Seven

RACES, PULLS, AND MORE

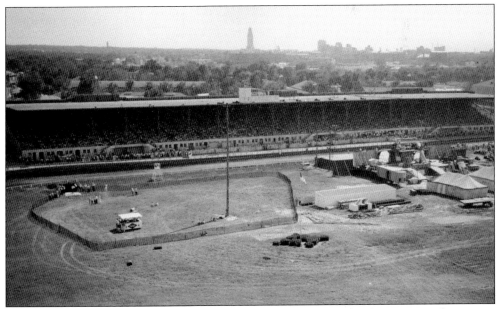

The grandstand seats are filled with a crowd that anticipates a great performance on the stage or the racetrack in the 1930s. Downtown Lincoln shows up on the horizon, with the majestic tower of the Nebraska State Capital Building in the center of the image.

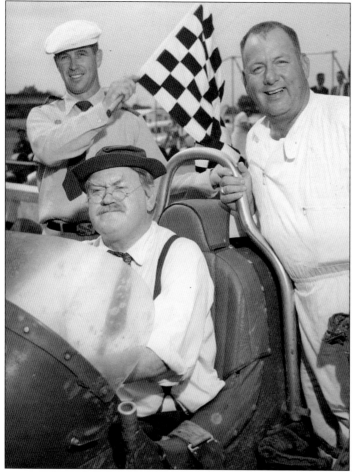

In the photograph above, Charlie Weaver wins the checkered flag in 1961. The exhibition race entertained the crowd before the car races in front of the grandstand. Weaver (pictured in a race car at left while receiving the checkered flag), born as Cliff Arquette in 1905, was a well-known comedian on television after creating the character of Charlie Weaver for the *Jack Parr Show*. He also played Mrs. Butterworth in television commercials. Arquette died in 1974.

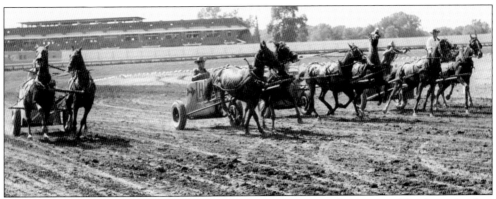

A newer attraction in front of the grandstand was a competitive chariot race. Two horse hitches pulled the rubber-tired chariots around the track at a fast pace. Unfortunately, September 1970 news articles reported the death of two horses in the chariot race.

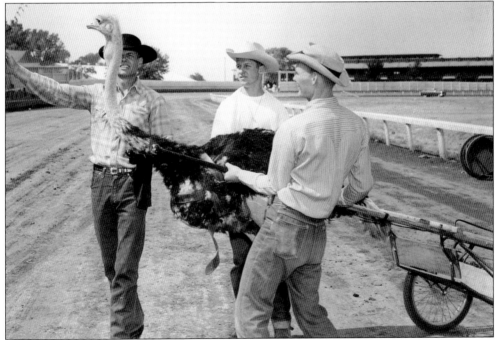

Three cowboys have their hands full with an ostrich that either objects to the harness or is overly eager to start the race. The records and photographs of the ostrich races were taken during the 1955 state fair.

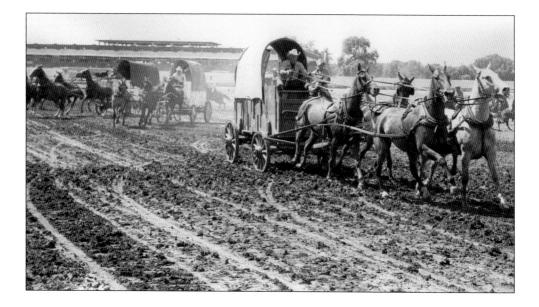

Covered wagons pulled by four-hitch horse teams fly around the far turn in front of the grandstand. In this 1970s photograph (above), at least four horse-and-wagon teams are vying for the win in this race on a dry track. In the image below, there are four riders whose striped shirts match the driver in the striped wagon. They appear to play a part in keeping the horse and wagon on course and remain close to help. What is seen of the name on the front of the wagon bed is Gary Koland. The front leg of another team's horse can be seen on the left side, running in a close second place.

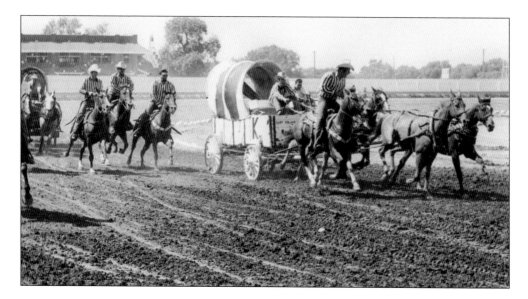

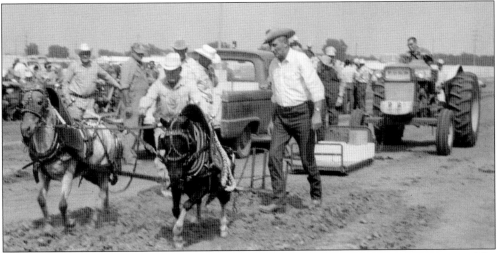

A pair of ponies pulls a sled with a layer of concrete blocks in the 1970s pony competition. The tractor following the weighted sled has a chain attached to the rear of the motorless machine. After the ponies have exhausted the length that they can pull, the tractor will pull it backwards to the starting point. It will then be hitched to the next team to be in line for their pull.

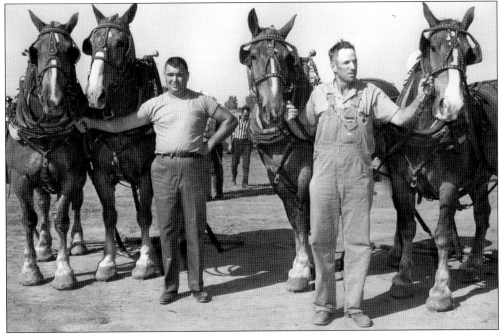

Two men hold onto their teams' halters as they wait in line for their turn to compete in the 1969 draft horse competition. Seeing the men stand by the horses provides a point of reference to appreciate the animals' massive size and power evident from their muscular legs and bodies.

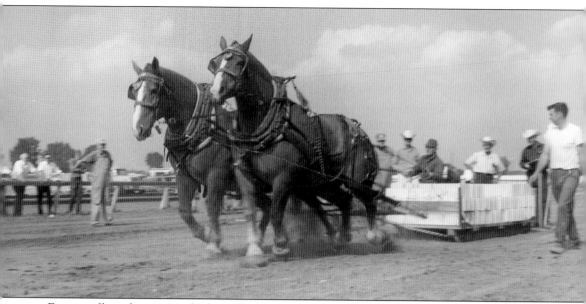

From small-sized ponies to the large draft horses, not only do the horses get bigger, but the sled does as well. The concrete blocks have grown in number and layers. There are now three layers of concrete blocks for these large horses to move along the ground.

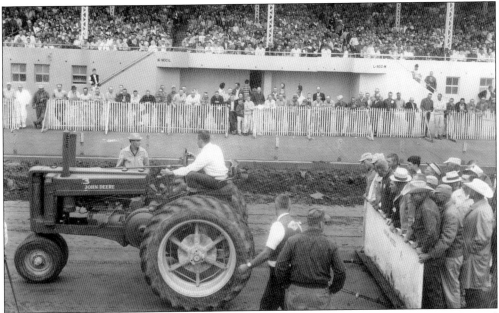

This 1970s photograph illustrates a switch from two horsepower to a much higher mechanical horsepower in tractor pulls at the Nebraska State Fair. In early pulls, men riding on the sled served as the weight. As the tractor power increased, so did the number of men on the load. The power of the pull to draw a capacity crowd is evident in the overflow of spectators standing by the fence and on the steps.

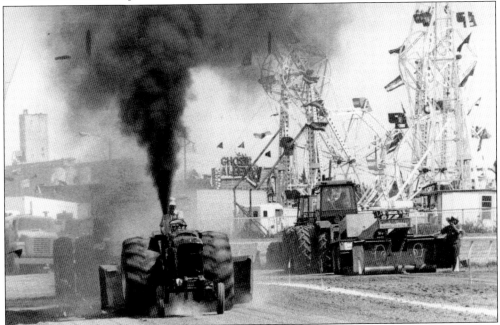

Black exhaust fills the air above this high-powered tractor as it pulls a mechanical sled. Men who rode on the sled above have been replaced by technology that automatically increases the weight being pulled. The midway is behind the track area to the right. A Ghost Alley fun house sign is visible up near the exhaust cloud, and a spare sled is parked on the right side of the pull area.

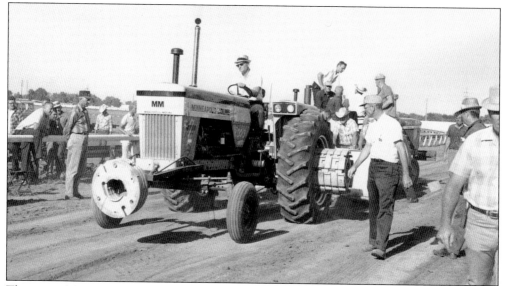

This powerful Minneapolis Moline has the number "18000" written on the side for its class entry. Heavy weights have been added to the rear wheels and the front end of the tractor to stabilize it. This helps keep the front end on the ground as the weight increases on the sled. A judge walks alongside to end the pull when there is no more advancement of the tires.

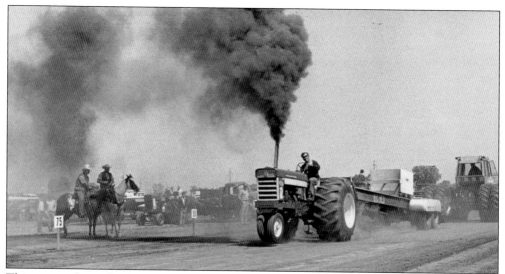

This picture shows the 50- and 75-foot markers along the track. The weight automatically moves up the incline and increases the pounds pulled. The tractor behind the sled follows to pull the sled back after the present tractor quits moving forward and the distance pulled is certified. Two from the state fair security force watch from their mounts.

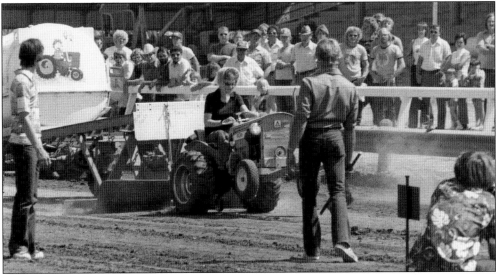

In 1976, women joined the competition in the garden tractor pull. Seen above, the tractor has come to the end of its capability, and the front end lifts off the ground. The driver is pulling with an Allis Chalmers 810 tractor as the judge watches, ready to wave the flag to end the pull.

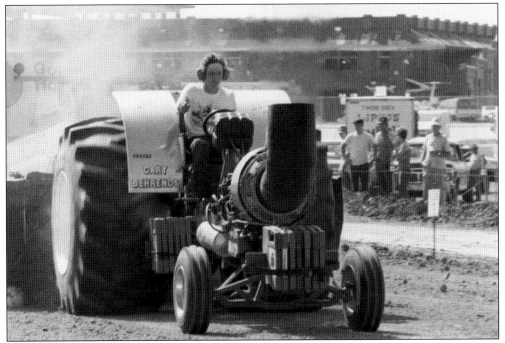

Modified tractors joined the field in this 1978 contest. This unusual-looking tractor is loaded down with extra weights on the front and sides. The fender lists the owner as Gary Behrends. The rider wears ear protection, as the engine sounds rise to a painful pitch as the power used increases.

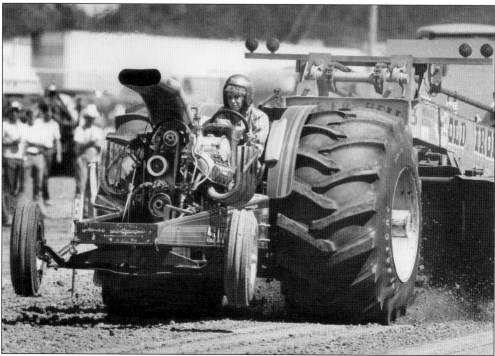

Julie Sporhase brought her modified tractor all the way across Nebraska to Lincoln from Holyoke, Colorado, in hopes of winning the top prize in her class at the state fair. The tractor is named the *Sting* and notations at the bottom of the photograph claim a "484 cubic inch Hemi engine." She is rated third regionally and pulled for 164 feet and 11 inches. The sled is called *Old Ironsides*.

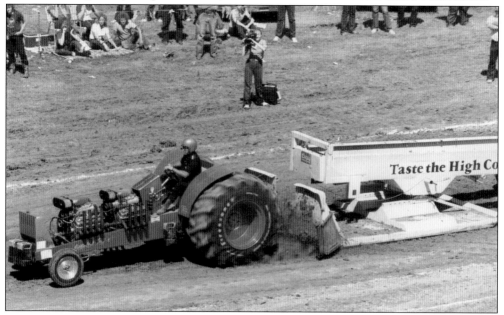

As the years passed, pullers came with extreme machines that only remotely resembled a tractor. This modified tractor has an extended engine area and, except for the large back tires, resembles a race car. This mechanical sled has been given the title *Taste the High Country*.

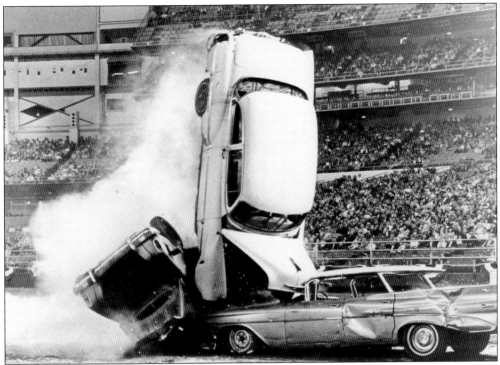

The daredevil drivers put on a death-defying show for the grandstand audience. In this act, a car launched from a ramp at high speed flies through the air to land beyond two cars or, in this instance, on top of them.

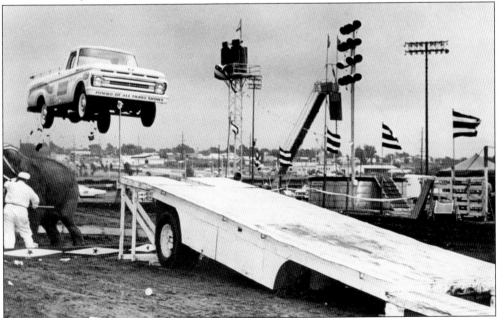

A Thrillcade show was one of the more popular attractions in the mid-1900s. Clods of dirt are flung from the spinning rear wheels as a pickup jumps over an elephant to land on the far ramp. The bumper reads, "Jumbo of All Thrill Shows."

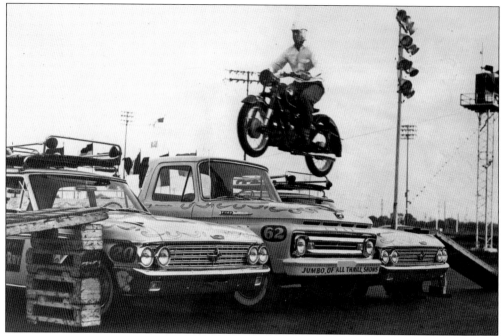

Not to be outdone by a pickup launch, this motorcyclist dares to jump from ramp to ramp and clear three vehicles. The pickup in the middle advertises the "Jumbo of All Thrill Shows" on its bumper. The vehicles are pinstriped, and a decal on the side of the first car, No. 20, advertises a derby.

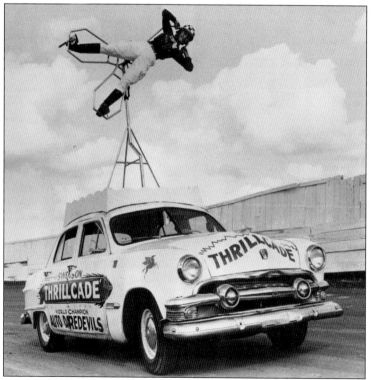

A daredevil acrobat spins above a speeding car in a performance of Swenson's Thrillcade of the World Champion Auto Daredevil show. The rooftop rider hangs on without a visible safety harness to catch him if he should spin off his perch.

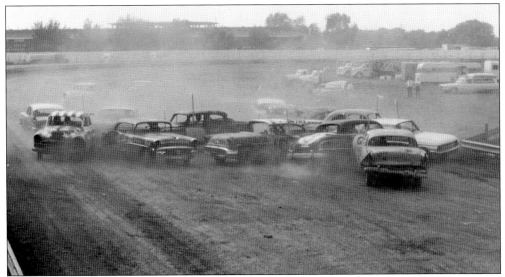

Nonprofessional drivers entered this demolition derby in 1969. The cars have been stripped of glass and interior seats and coverings and then reinforced under regulations for safety of the driver. The rules require contact in a certain time period, and the winner of each heat proceeds to a championship round. The second-place winners of each heat usually enter a consolation heat.

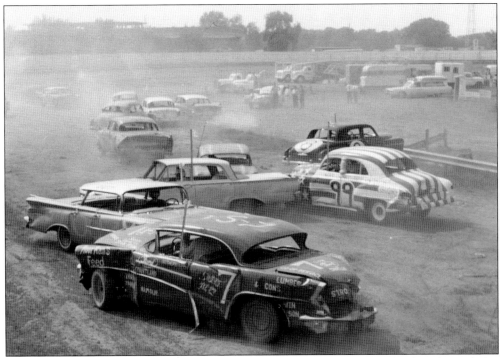

Tow trucks, wreckers, and an ambulance stand by in the center field for the demolition derby. The narrow stick by the driver's window must be snapped off when the car is out of commission to prevent any further hits. Deliberate contact with a disabled vehicle can disqualify the driver that is still in contention. Dust flies, tires smoke, and metal screeches until all but one or two cars are still moving.

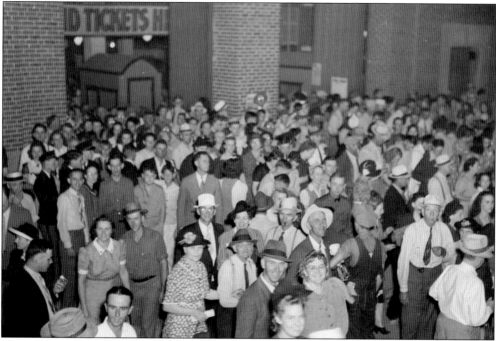

This photograph offers a partial view high above the entrance of the grandstand. This image shows the 1940s patrons milling around in front of the ticket windows area. It would seem that they are exiting after an event that just concluded in front of the grandstand.

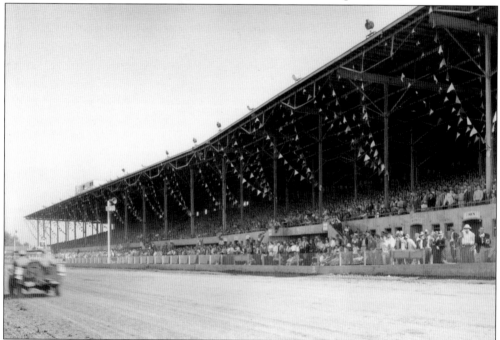

This crowd waits for the start of a race in 1955. The only car visible is going down the track in front of the grandstand, perhaps checking out the condition of the track. The photograph provides a good view of the old grandstand, which was replaced in the late 1970s.

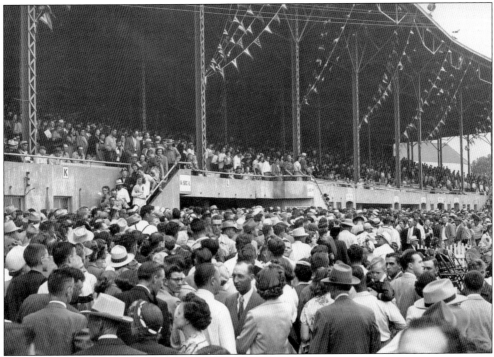

Attendance numbers run high and leave only standing room in the grandstand. The 1950s drew record attendance with good weather and popular entertainment.

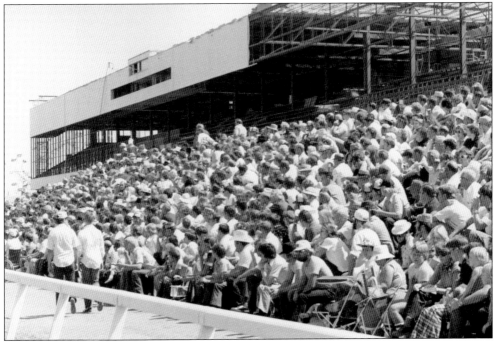

The Nebraska Legislature approved the building of a new grandstand in 1974, and the old one was demolished in 1975. A total of $1.2 million in bonds were also issued for a new track and horse barn. The new grandstand was completed in 1978, and the progress is shown here in 1977.

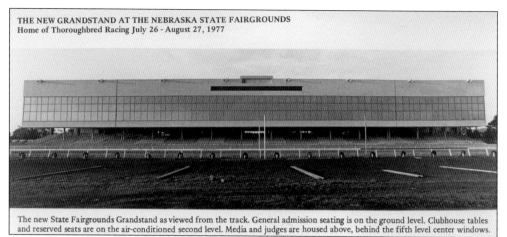

The new State Fairgrounds Grandstand as viewed from the track. General admission seating is on the ground level. Clubhouse tables and reserved seats are on the air-conditioned second level. Media and judges are housed above, behind the fifth level center windows.

Seen here is a photograph of the grandstand now finished at the state fairgrounds. General admission seats are on ground level, while clubhouse and reserved seating is available on the air-conditioned second level. Media and judges are housed in the center behind the fifth-level windows on top. (Courtesy of *Nebraska Farmer Magazine*.)

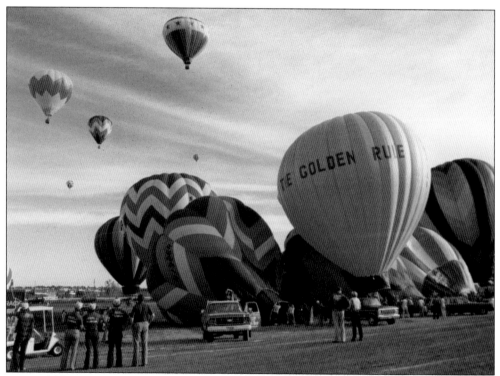

Hot air balloons are inflated and released to fill the sky above the Nebraska State Fair in 1979. Twelve balloons are shown in various states of preparing to lift off and join the five already rising in the air. Three balloon rallies had to be canceled in 1989 due to rain during fair week.

Eight

PARADES AND BANDS

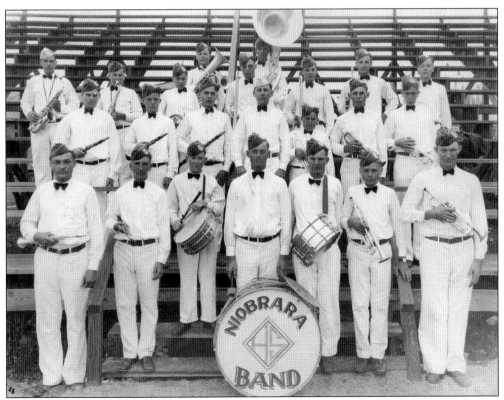

The very first band performed at the 1869 fair in Nebraska City, but high school bands were first seen at the fair in 1927. This photograph was taken of the Niobrara band from Northeast Nebraska in the late 1920s. The images does not indicate whether it is a high school band or a community band.

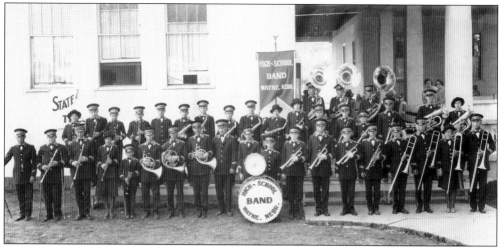

The Wayne High School Band was one of the first bands introduced at the Nebraska State Fair in 1927. This coed band included members of all ages. Note that one of the members to the left stands with crutches, and next to him is the drum major who holds his baton and no instrument. The ladies in the band wore skirts, jackets, and a more feminine-style hat for their uniforms.

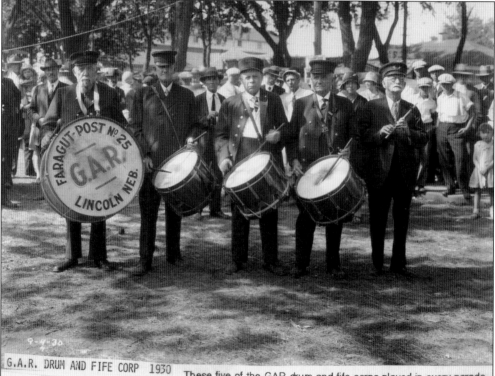

G.A.R. DRUM AND FIFE CORP 1930

These five of the GAR drum and fife corps played in every parade held in Lincoln for more than 30 years. I remember well them performing at the Nebraska State Fair for many years.

The information included at the bottom of this photograph taken September 4, 1930, states that these five members of the Grand Army of the Republic (GAR) drum and fife corps played in every parade in Lincoln for more than 30 years. These older gentlemen represent the Faragut Post No. 25.

The 1927 Fairfield High School band wears capes as part of their uniforms. The boys' hats have brims, while the girls' beret-style hats are brimless. This band is also one of the first to take part in the state fair.

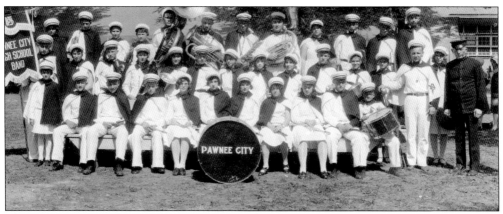

The Pawnee City High School Band poses for a 1929 group photograph. Uniforms adorned with capes were in vogue, and this band wears a dark-colored cape with a white uniform. The band instructor seen to the right is in a dark uniform and sports a matching cape.

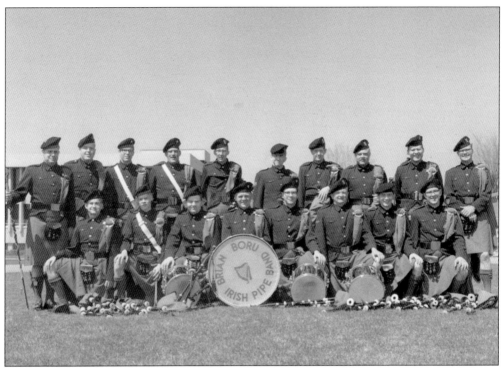

The all-male Brian Boru Irish Pipe Band performed on August 31, 1974, at the state fair. Their instruments were bagpipes and drums, and their uniforms were kilts and beret hats, with a sash tied and draped over their left shoulder. Each had a tasseled bag hanging around the waist. The drum major stands on the left in the back row.

This band marched on the state fairgrounds during the 1940s. The insignia on their helmets is not decipherable, but the uniform has a military look. The instruments that can be seen are only drums and trumpets or coronets. The members appear to be of a more mature age than high school students.

The Fairbury band marches on the track in front of the grandstand for the parade in the 1940s. The drum majorette struts along the inside fence rail. Her uniform is reversed in color from the body of the band and includes a white jacket and dark trousers. She wears a white hat without the feather in the front.

This unidentified band of the 1940s has added baton twirlers to its group. The very youngest member of the band marches directly behind the tall and slender drum major. The disparity in their heights serves to accent her short stature.

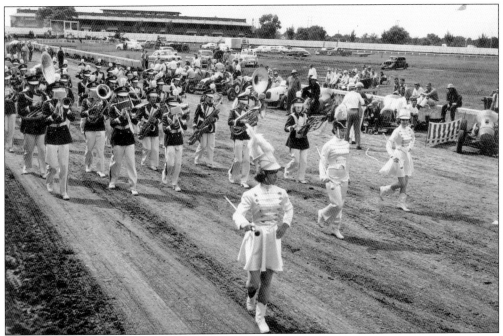

Race car drivers have parked their vehicles along the inside rail of the track to enjoy the parade in close proximity to the participants. Exhibitors follow the bands with their horses and livestock. An emergency vehicle faces all the entertainment in the center of the field.

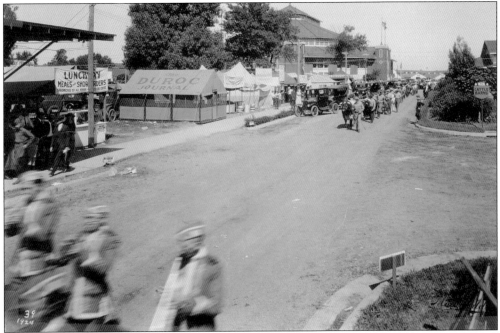

The 1924 state fair livestock parade is led through the fairgrounds by a community band. The parade progresses up the street from the white livestock barns and past automobiles parked on the side of the street. They follow the avenue past the vendor tents. The large tri-level roof is on the livestock-judging pavilion.

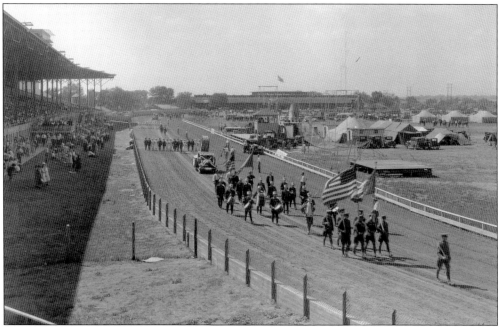

A state fair parade in 1931 presents colors in the lead, followed by the armed services groups in a decorated truck float. A photographer records the event from beneath a hooded camera on a tripod. The center field is filled with props for high-wire acts above a safety net. Three stages, a multitude of tents, and cars sit in the open space. A herd of draft horses stands in the middle.

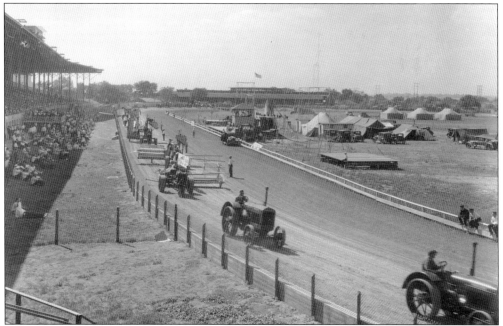

The long line of tractors and farm equipment follows the flags, bands, and military groups. This is a continuation of the parade on September 10, 1931. The beginning of the parade is in the previous photograph. A few onlookers rest on the ground in front of the grandstand as they take in the sights.

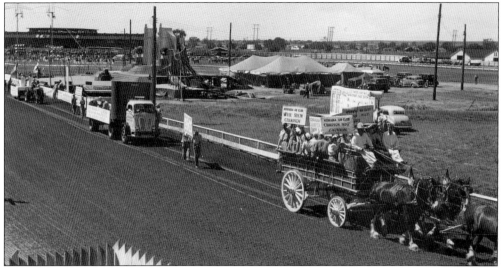

The Budweiser Clydesdales take part in the 1940s state fair and parade for the first time. The wagon is filled with 4-H club champions. A band is assembling in the center field, and again, the farm equipment and tractors line up to the left around the bend. Across the middle of the field are the circus elephants, and an elaborate stage is erected across the track from the grandstand.

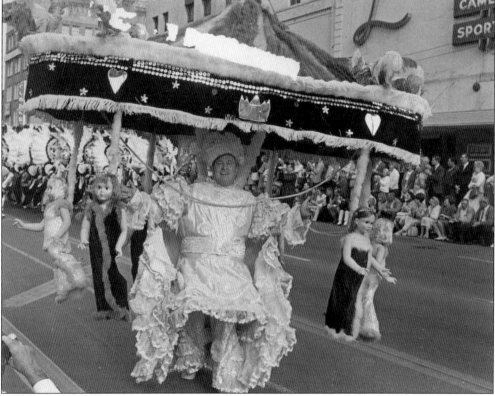

In 1967, the state fair parade took to the streets in downtown Lincoln. This gentleman entered his display of dolls hanging from a large, elaborate headdress. He called his lacy attire and the fancy headdress the "flamboyant man" float.

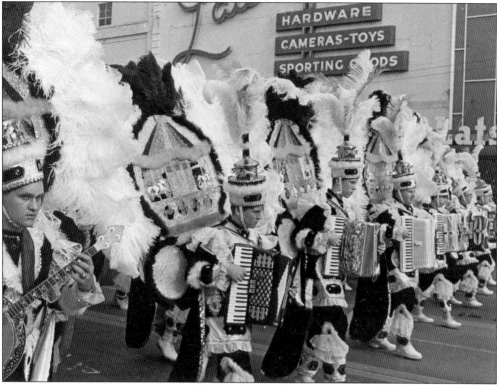

This accordion troupe in all their finery followed the flamboyant man float in the parade. These outfits were fancy enough to rival their predecessor for the winning prize in 1967. The feathery hats and intricate costumes look like a heavy load in addition to the detailed piano accordions.

Three Horse Club members from Cozad carry banners and the American flag in the 1940s state fair parade. They are followed by twirlers and a band.

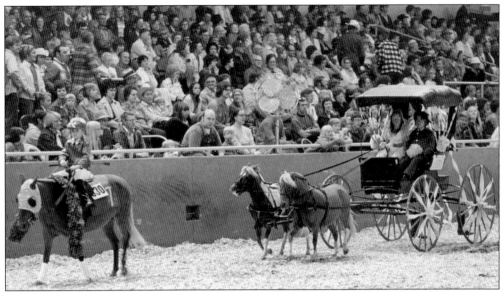

The costume parade for young contestants and their ponies ride around the arena in front of a large audience. A young lad has his jockey suit on and sits astride the winner of the horse race. A flower wreath is thrown across the front of his saddle. The four-wheeled carriage on the right has two small ponies pulling newlyweds. In this marriage, the bride handles the reins.

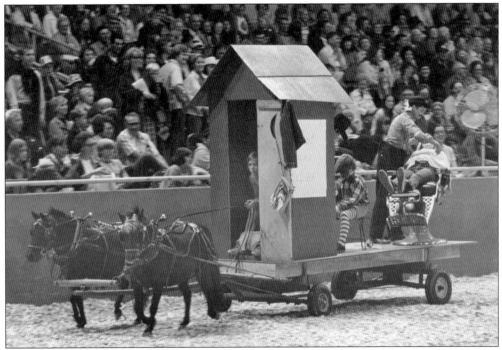

Another entry in the costume parade for young people was an outhouse with an occupant on the seat guiding the pair of black ponies. The proverbial telephone book hangs within reach on the door. On the back of the flatbed, a barber prepares to shave a customer. A fourth boy sits behind the outhouse with a darkened face. The sign on the outhouse reads "Rest, Relax, Relief."

The Klown Band from Plainview has entertained at the Nebraska State Fair for several decades. The Plainview Klown Doll Museum in Northeast Nebraska began with one doll placed on a windowsill in the library. From there, it has grown to a museum with approximately 7,000 items and a local band.

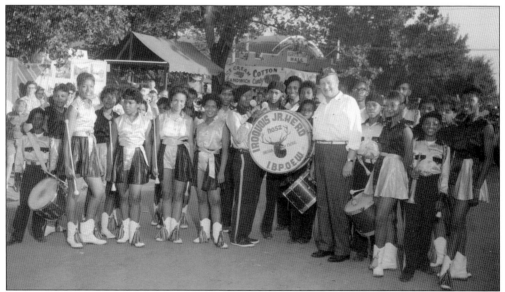

The Iroquois Jr. Herd Band was sponsored by an Omaha Improved Benevolent Protective Order of the Elks of the World (IBPOEW) No. 52 club. This is an energetic African American group that performs intricate dance and choreography on the streets of the state fair. This band performed with twirlers and drummers at the request of state fair organizers in 1960s. Members are seen here with their sponsor.

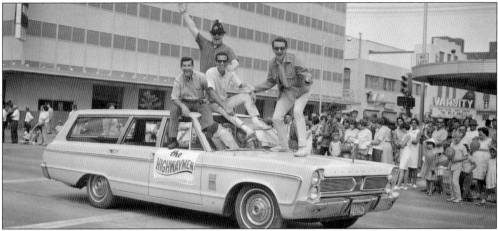

The musical group the Highwaymen ride on the roof and hood of a station wagon in the Nebraska State Fair parade in 1966. The parade was taken through the streets of downtown Lincoln and enjoyed by spectators who crowded the sidewalks along the parade route.

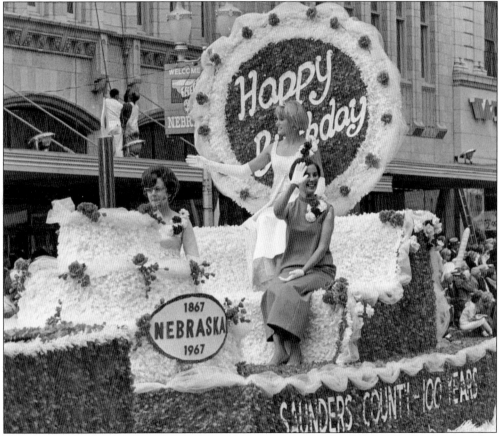

A float is decorated to celebrate Nebraska's birthday in the centennial parade. A queen and her attendants add to the beauty of the Saunders County float. This commemorates the 100-year birthday of Nebraska's statehood from 1867 to 1967. Two people in the upper left side of the picture on top of a store awning seem unaware of the passing parade.

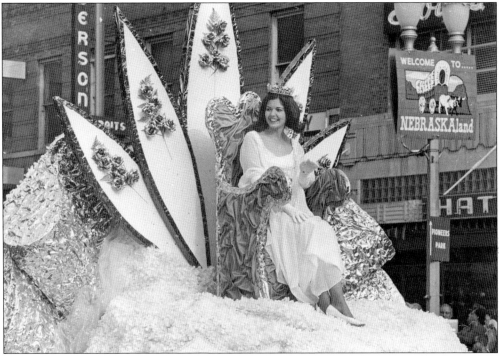

The year's official Centennial Queen, Nancy Griffin, rides on her throne atop this beautifully decorated 1967 float. The Nebraskaland logo welcomes all visitors to Lincoln and hangs on the lamppost to the right. The smaller sign below directs people to Lincoln's Pioneer Park.

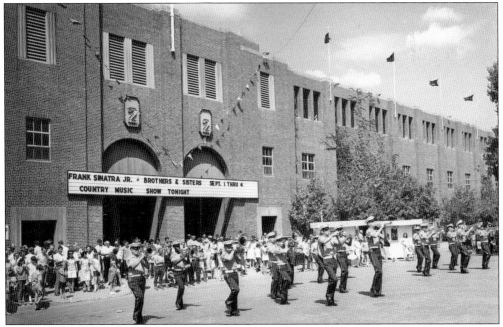

The Marine Corps Band marches in front of the entrance to the coliseum. The building marquee advertises the shows scheduled for September 1 through September 4 in 1969. A country music show is on the program for that night.

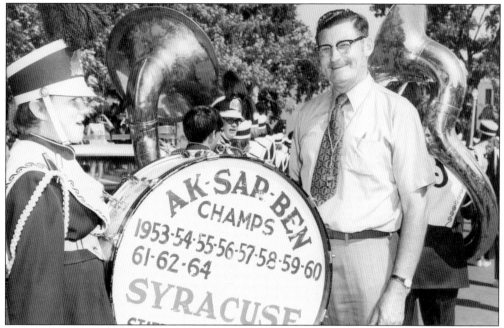

The Syracuse High School band has decorated its bass drum in recognition of their 10 years as champion at the Ak-Sar-Ben competition. After missing out in 1963, they began a new winning streak. Ak-Sar-Ben is Nebraska spelled backwards. The band also won high honors in the state marching contest for four years. They still have room to receive and record a few more championships on the drum.

This unidentified band features a drum majorette leading the band through its musical scores. The kettledrums up front add a deeper sound to the band's performance at the state fair in the late 1970s or early 1980s.

Nine

CANDID CAMERA SHOTS

Henry Brandt Jr. followed in his father's footsteps for his love of the state fair, and he eventually became a manager of the Nebraska State Fair. He served in that capacity as a determined and dedicated leader for 23 years, from 1964 through 1987. He was known by many as "Mr. Nebraska State Fair" and was the last manager to live on the fairgrounds. He attended the state fair at the tender age of 2, won second place in the 4-H dairy show at the age of 14, and for 74 years of his life, he lived and breathed his hobby—fairs. He was saddened by the loss of the location in Lincoln but was looking forward to the new fair opening in Grand Island. He died August 3, 2010, about three weeks before the grand-opening ceremony.

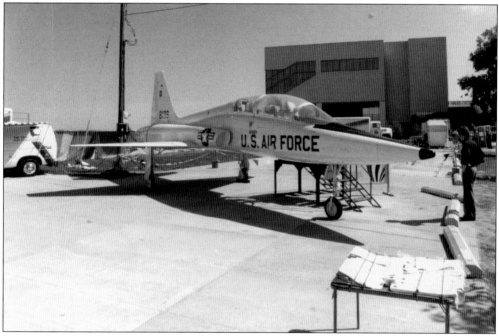

Winner of a first-place prize medallion in 1928 was Frank Arnold, age eight, of Miller, Nebraska. He and his three siblings arrived in Kearney earlier that year on the Orphan Train from New York. He found a home with Faye and Scott Arnold of Miller. Though he had never attended school, he was placed in the third-grade class in District 5 of Buffalo County. His teacher chose this pencil drawing of a wagon for an entry at the Nebraska State Fair. (Courtesy of Patty McNutt.)

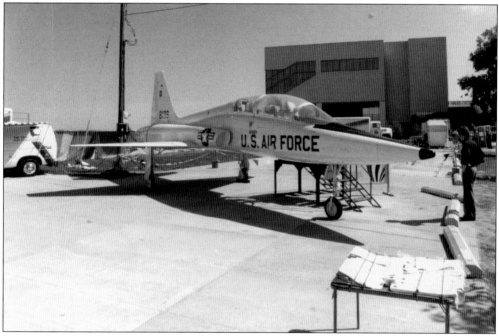

Several branches of the armed services had recruiting booths and equipment set up at state fairs. In 1980, the Air Force brought a jet for viewing and parked it near the Devaney Center near the south entrance to the fairgrounds.

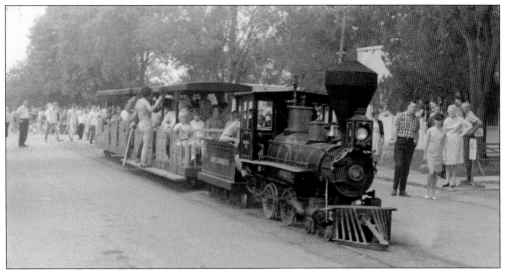

Henry Brandt Jr., longtime manager of the state fair, wanted to make travel around the fairgrounds easier for all attendees. He decided a shuttle train would be the thing to accomplish this goal. Pictured here is the new train in September 1968, referred to later as Brandt's Folly. Many enjoyed free rides as they took advantage of the transportation.

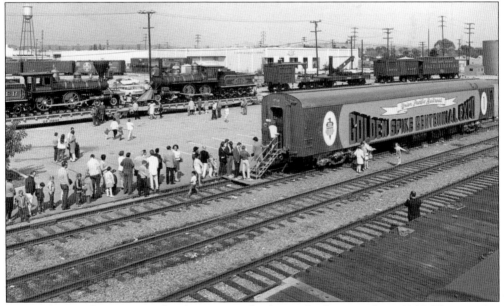

The Golden Spike Centennial railcar was on display at the fairgrounds in 1966. The crowd is lined up to walk through the exhibit, which commemorates the memorable pounding of the spike at Promontory Summit, Utah, when the rail lines met.

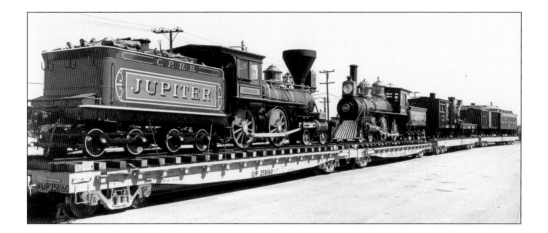

The famed engines that met at Promontory Summit, where the railway became one from East to West across the United States, were brought by rail to the state fair. The *Jupiter* and Rogers Engine No. 119 are seen in this 1966 photograph. Gov. Norbert Tiemann attended the reenactment at the fair with a group of dignitaries, as well as Henry Brandt Jr. Below, they prepare to use a sledgehammer to drive the spike into the rail. Historical artifacts were set up in the accompanying centennial railcar, which was kept in its original state.

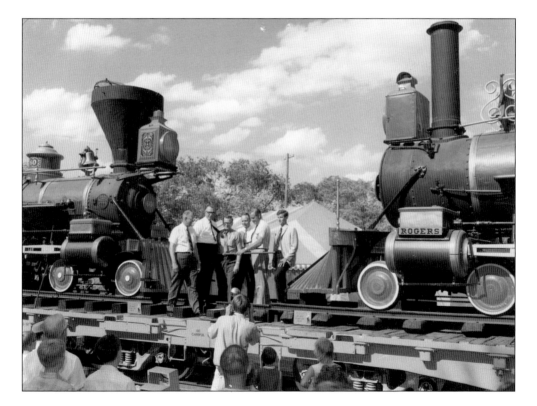

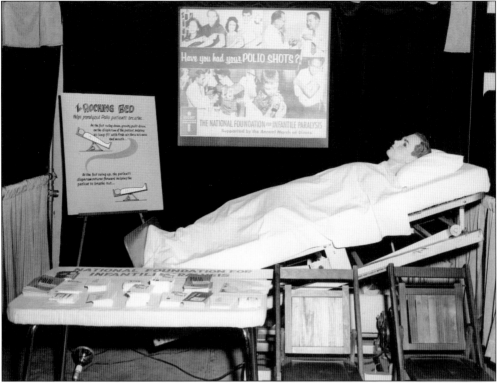

In the Department of Health booth in
1957, a rocking bed showed how victims
of infantile paralysis, commonly known
as polio, were assisted in breathing. The
motion of the bed was to help inflate and
deflate the lungs. A nationwide program of
inoculations and vaccines helped eradicate the
devastating disease and stop the epidemic.

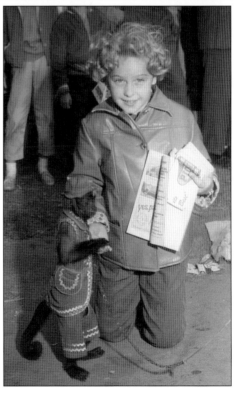

A young girl makes friends with a monkey
who is greeting the crowd with handshakes
and seeking treats. This monkey and
his owner were part of the wandering
entertainment during the 1950s state fairs.

Standing behind Ed Schultz are, from left to right, agent Frank Taylor, Jimmy Dean, and Erv McCardil in the state fair office during the 1950s. Jimmy Dean performed onstage at the fair.

From left to right, Dennis Day, state fair manager Ed Schulz, and agent Frank Taylor look at the state fair magazine. The magazine cover shows the cars lined up for entrance to the new gate in the mid-1950s.

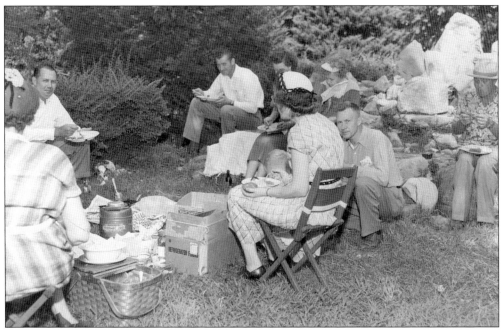

Families brought picnic lunches to enjoy during a noon break at the state fair. A picnic basket sits near a Thermic Jug. Wooden Folding chairs and large rocks provide the seating, and the gentleman on the right appears to be eating a piece of fried chicken. Real glass dishes were not replaced by paper plates in this gathering dating back to the 1960s.

State fair board member Al Olson enjoys the company of the famed Doublemint Twins. Joan and Jayne Boyd of Hammond, Illinois, became famous for a Wrigley's Doublemint Gum commercial in 1959 and reigned for four years in the celebrity spotlight.

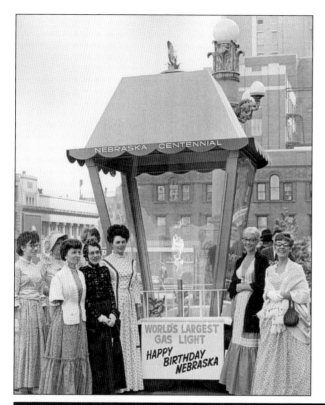

The Nebraska centennial year of statehood was 1967. These ladies dressed in period gowns brought the World's Largest Gas Light to Lincoln for the celebration. They are posing on a Lincoln street to wish a Happy Birthday to their home state of Nebraska.

At a young age, Dallas Hinnrichs of Stanton received the championship trophy for the 1971 tractor pull. He and his brothers participated in many pulls, both locally and at the Nebraska State Fair. This trophy was presented by Dan Sebold of the executive board.

Ten

THE GRAND OPENING

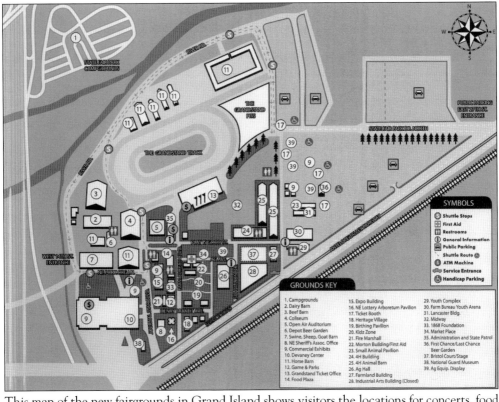

This map of the new fairgrounds in Grand Island shows visitors the locations for concerts, food vendors, restrooms, and the outstanding activities planned for the inaugural commencement of all future Nebraska State Fairs. The state-of-the-art buildings were erected 15 months prior to opening day at an estimated cost of $40 million. The square footage of each building is listed. The final attendance numbers exceeded expectations when 309,400 people poured through the gates. There were more commercial exhibits contracted for the new exhibition hall. The livestock competitions brought in a record number of entries in 4-H, FFA, and open-class events. Longtime vendors followed the fair to its newest locale, and new stands came and recorded good sales. The Nebraska Cattlemen's Beef Pit restaurant exceeded their previous record of meals and sandwiches served in the 10 days of the fair.

New Facilities

70,000 Sq. Ft. Exhibition Building

This exhibition building is designed with an open floor plan to accommodate a variety of events. The building includes a concession area, ample storage, concrete flooring and is climate controlled. The building exterior is precast concrete panels with prefinished metal siding panels and brick veneer.

❖ Approximately 70,000 sq. ft (180' x 386')
❖ Fair use - 4-H and FFA exhibits
❖ Non-Fair use - indoor sports courts
❖ Concession area

100,000 Sq. Ft. Exhibition Building

This building is the largest exhibition building being built on the grounds, is the ideal setting for conventions, trade shows, and corporate events. This building offers dual food service areas, ample storage, concrete flooring and is climate controlled. The building exterior is precast concrete panels with prefinished metal siding panels and brick veneer.

❖ Approximately 100,000 sq. ft (224' x 450')
❖ Fair use - commercial and agriculture vendors
❖ Non-Fair use - conventions, tradeshows, home/garden shows, recreation/sports shows
❖ 1 concession area and one full-sized kitchen

Cattle/Sheep Arena Building

This building is a state-of-the-art facility that provides year-round opportunities for a variety of events. With ample room and first-class amenities, it is the premiere location for local, regional and national events. The building exterior is precast concrete panels with prefinished metal siding panels and brick veneer.

Cattle Section	Sheep Section	Arena Section
❖ 109,076 sq. ft. (approx. 285' x 382')	❖ 88,692 sq. ft. (approx. 232' x 382')	❖ 57,390 sq. ft. (approx. 312' x 218')
❖ Fair use - cattle stalls and displays	❖ Fair use - sheep, goats, livestock	❖ Fair use - show arena
❖ Non-Fair use - livestock, horse, trade, and recreation/sports shows and sales; tool, book, electronic sales	❖ Non-Fair use - livestock, horse, trade, and recreation/sports shows and sales; tool, book, electronic sales	❖ Non-Fair use - rodeos, automotive and recreation shows, tool and book shows
❖ Attached Barn Bar - 3,558 sq. ft	❖ Attached exhibition space (small animal exhibition, 1,952 sq. ft)	❖ Climate controlled
❖ Attached Milking Parlor	❖ Attached Birthing Center (2,019 sq. ft)	❖ Seating for 2000
❖ Stalling for 1,400 cattle	❖ Pens for 1,600+ small animals	❖ Configuration for a full-sized rodeo
❖ Flooring - concrete	❖ Flooring - concrete	❖ Private room overlooking arena

These photographs are impressive, but a visit to the actual fairgrounds and a walk through these grand structures bring home the expertise involved in the development and construction of a dream site for the 141st year of the Nebraska State Fair. The versatility of the buildings will be invaluable for events that may be held at Fonner Park year-round.

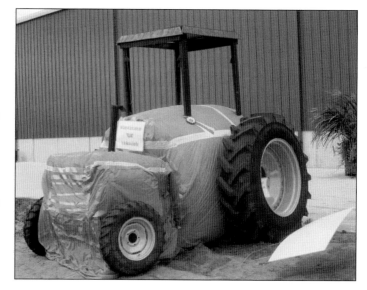

A hay-decorating contest in which bales of hay are made to look like other objects was held before the 2010 state fair, and this John Deere tractor was one of the top choices by official judges as a contest winner. This replica of a John Deere Tractor was the work of the Hall County 4-H Junior Leaders. The motto written on the white poster in front says the Hall County 4-H Leaders are "PULLING" for the Nebraska State Fair.

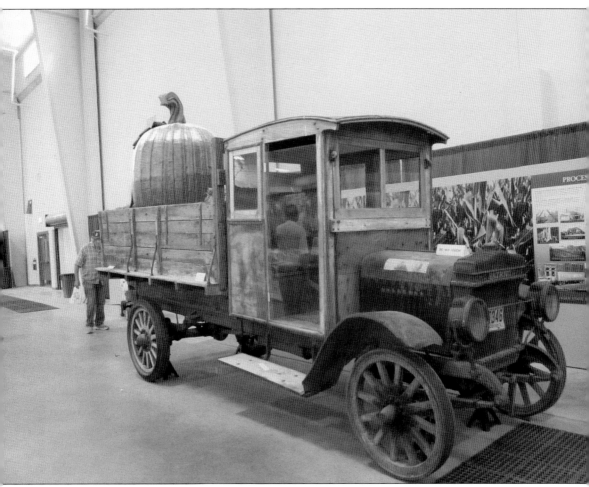

A wooden cab and wagon bed were built on this antique truck. The solid rubber tires have wooden spokes on the wheels. This vehicle was propped up on jack stands inside the main entrance of the 4-H and FFA Building. On the front of the radiator above the license plate, a model name identifies the truck as a Patriot. A 1918 Patriot identical to this one was purchased for the Museum of Nebraska History. A.B. Hebb Motors manufactured Patriot trucks in Havelock, Nebraska, a suburb of Lincoln, from 1918 to 1924.

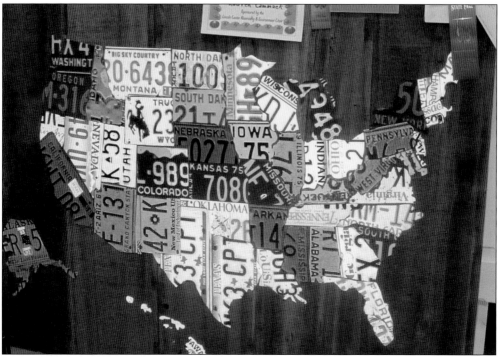

Laura Cammack from Gage County won the outstanding 4-H Waste Buster Exhibit award for her idea to use old vehicle license plates. They were cut in the shape of each state whose name was preserved and visible on the collage of the continental United States. The states of Alaska and Hawaii are down in the left corner of the old wooden barn door used for mounting the display.

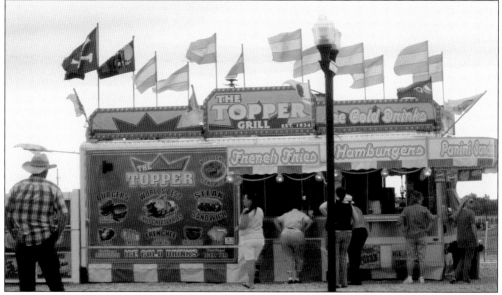

The Topper Grill was a familiar sight for those who had enjoyed their hamburgers, french fries, and cold drinks in Lincoln at the state fair for many years. It opened its stand and counter in Grand Island to greet customers, both the new ones and faithful followers from the past. The stand is prominently located near the 4-H/FFA Exhibition Building and the activities in the Kids Zone.

This Nebraska quilt greeted visitors to the quilt show as they walked in the northeast door of the new Exhibition Building. The 1994 state fair marked the Quasquicentennial celebration for 125 years of history. This quilt was one of three separate large hangings, with every county represented that sent in their own specially designed quilt block. This year boasted a record-breaking number of 704 quilts entered in the competition.

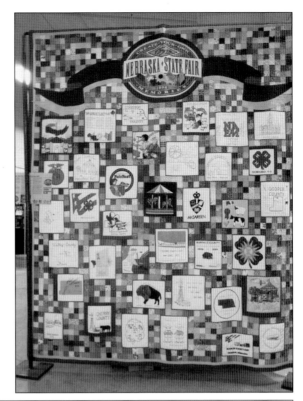

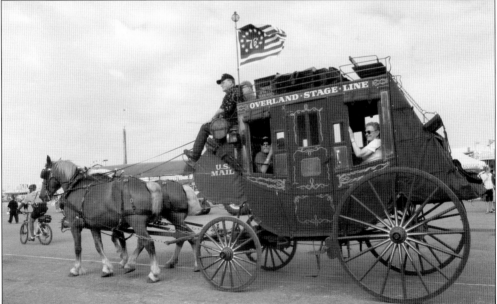

The grand marshals for August 31, 2010, were honored with an Overland Stage Coach ride. Francis and Pat McDonnell of Phillips were the honorees. Leon and Dolly Meyer, Broken Bow; Carroll Ebner, Columbus; Ron Gade, Seward; Larry Wilcox, Minden; Robert and Joyce Beeleart, Page; Dennis and Pam Bauer, Ainsworth; and Dale and Cindy Berndt of Lakeside were all recognized as grand marshals for 2010. Each was honored in turn during a daily parade.

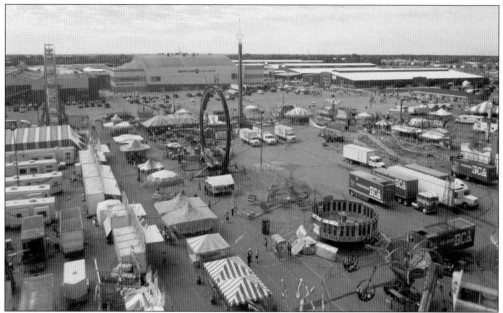

Camera shots from the top of the double Ferris wheel offer a bird's-eye view of food and game tents, as well as familiar rides brought in by Belle City Amusements and the new Nebraska State Fairgrounds. The Heartland Center dominates the middle and is flanked by the Exhibition Hall and livestock barns to the right. The grandstand and racetrack lay to the left. The second photograph shows the early-morning crowd entering from the parking lots toward the main ticket gate on State Fair Boulevard. The permanent white building is the Welcome and Information Center. A first aid center and mothers' nursing lounge are located on the north end of the building. Ambulances stand by for emergencies. The striped tents are in the US Cellular Kids Zone. Hedrick's Petting Zoo and Hedrick's Camel and Pony Rides are favorites of the younger generation.

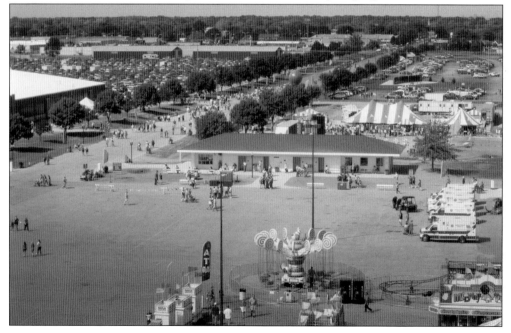

Paul Messerschmidt, Missouri Valley, Iowa, follows his trained gaggle of geese as they walk about the fairgrounds. Known as "Mr. Goose Man," he follows the meandering geese with his walking stick and helper. The geese are trained to understand voice and hand commands. He started with 13 goslings in 2004. They have walked over 711 miles, and to his benefit, he has lost more than 220 pounds.

The largest indoor video screen in the Midwest hangs on the wall in the livestock arena. The 34-by-12-foot screen offers fairgoers a close-up view of activities and events. Its fiber-optic connection to all buildings is broadcast in high definition. The wireless network covers over 100 acres of the grounds. Live events from the fair may be video streamed throughout Nebraska in the future.

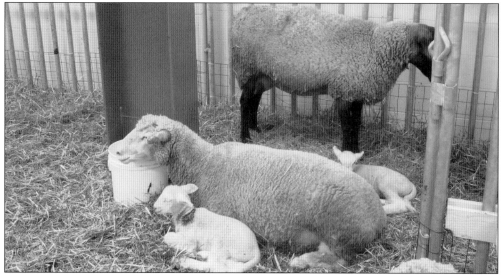

The Birthing Pavilion moved with the state fair and was improved at the new location in Grand Island. A large climate-controlled area is welcomed by workers and visitors alike. This move from a tent brings the expectant and new mothers with offspring into a modern facility located in a brand-new building. These newborn twin girl lambs rest comfortably next to their mother ewe. They may be viewed from the outside through large windows or from inside the room. The lambs were less than a day and a half old when photographed. The newborn calf below lies in soft fresh hay next to its mother. It is 36 hours old and is tended to by Dr. Virgil Heyer in connection with the University of Nebraska-Lincoln Meat Research Facility at Clay Center. Volunteer pre-veterinarian students are also in constant attendance.

A pair of giant Lee bib overalls has a storied history going back to the 1930s. The Lee Company, a maker of denim clothing, donated this 22-foot-long pair of overalls to be placed on tall poles at the front gate for advertising purposes. About 40 years later, Erv Moorberg, an employee of the Lee Company, received a call from the office in Kansas City to go pick up the overalls from the Lincoln State Fairgrounds. Despite many calls and inquiries that followed, nobody came up from Kansas City to retrieve those overalls. When news of the state fair's move to Grand Island was in the paper, Mary Lou Moorberg, wife of the deceased Erv Moorberg, contacted the Grand Island committee. Joe McDermott agreed to take possession once again of the 80-year-old overalls for display in the Exhibition Hall.

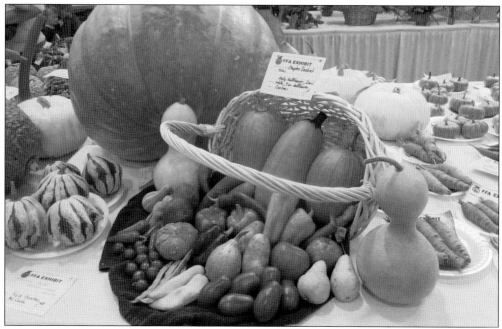

This cornucopia of fresh fruits and vegetables was arranged and displayed in an FFA exhibit by the three-person team of Molly Hoffbauer, David Walla, and Tim Hoffbauer from a central FFA chapter. The city or county location of the chapter's school is not listed on the exhibitor's entry ticket. The bright, multicolor fall produce basket caught the eye of the judge who awarded the team a purple ribbon.

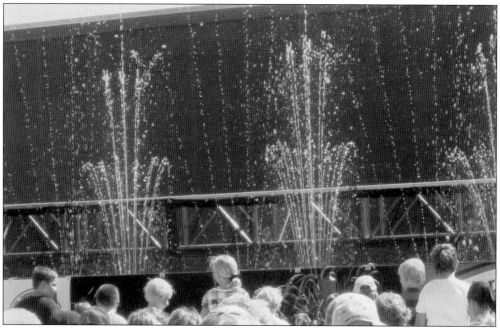

The Dancing Waters attract a big crowd of children who pushed to the front row to enjoy the mist drifting on the breezes. The pressure of the water feeding the fountains changed to perform a synchronized pattern of high to low, fine spray to heavy, and everything in between.

The Sept. 5, 2010
Nebraska State Fair Ag Family of the Day
The LeRoy Pieper Family

Every year, the Nebraska State Fair honors agricultural families who have been on the same land continuously for at least 100 years. The plaque they are issued is the Nebraska Pioneer Farm Award and is inscribed with the words "Presented with Grateful Appreciation By The Knights of Ak-Sar-Ben Foundation and the Nebraska Farm Bureau For 100 Years of Continuous Family Ownership." This year, the LeRoy Pieper family from Mitchell, Nebraska, was recipient of the award and was introduced, along with the family members who could join them, on September 5, 2010. From left to right in the photograph are Tim Pieper, son; Shirley McKee, LeRoy's wife; Sally Pieper, daughter; LeRoy Pieper; and Diana Ehrman, daughter. LeRoy and family members proudly rode in the Nebraska State Fair's parade on a fire truck as they celebrated the honor. (Both, courtesy of Sally Pieper.)

This hand fan was distributed to fairgoers. It shows the logo for the 2010 Nebraska State Fair. The fair is dedicated to the promotion of the state's agricultural industry. The barn gives nod to the livestock feeders and feed grain farmers of Nebraska. The windmills caught on as icons for the Nebraska State Fair. The idea was broached by Van Neidig of Battle Creek, a member of the state fair board.

Lindsey Koepke is the executive director of the Nebraska State Fair 1868 Foundation. The foundation's center is the spot for mementoes, souvenirs, shirts, hats, and brochures pertinent to the Nebraska State Fair. She has a demanding job overseeing the welfare of the donors, handling donations, and conservation of the history of the state fair.

www.arcadiapublishing.com

Discover books about the town where you grew up, the cities where your friends and families live, the town where your parents met, or even that retirement spot you've been dreaming about. Our Web site provides history lovers with exclusive deals, advanced notification about new titles, e-mail alerts of author events, and much more.

MADE IN THE
USA

Arcadia Publishing, the leading local history publisher in the United States, is committed to making history accessible and meaningful through publishing books that celebrate and preserve the heritage of America's people and places. Consistent with our mission to preserve history on a local level, this book was printed in South Carolina on American-made paper and manufactured entirely in the United States.

This book carries the accredited Forest Stewardship Council (FSC) label and is printed on 100 percent FSC-certified paper. Products carrying the FSC label are independently certified to assure consumers that they come from forests that are managed to meet the social, economic, and ecological needs of present and future generations.

FSC
Mixed Sources
Product group from well-managed
forests and other controlled sources

Cert no. SW-COC-001530
www.fsc.org
© 1996 Forest Stewardship Council

Find Your Place in History.

The new welcome sign at the gate to Fonner Park, home of the Nebraska State Fair, directs traffic into the new fairgrounds from South Locust Street onto Fonner Park Road. The left side of the sign can be automatically updated to advertise upcoming events, grandstand entertainment, and any announcements that pertain to the Nebraska State Fair, Fonner Park Races, or community events.